IMAGES
of America

EVANS AND ANGOLA

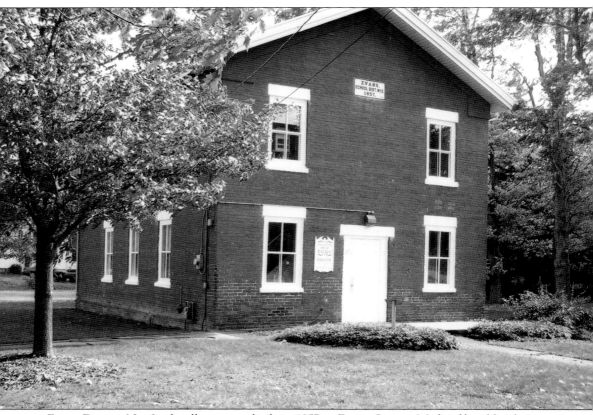

Evans District No. 2 schoolhouse was built in 1857 in Evans Center. Made of local brick, it was one of the few two-room schools in the area. It served the children of Evans for over 100 years. Today it is the property of the town and is used by the Evans Historical Society as a meeting place and museum. (Courtesy of the Evans Historical Society.)

On the cover: The beaches along Lake Erie were a primary draw in the summer. This photograph was taken in 1947 in the Point Breeze area near the Point Breeze Hotel. Summer visitors almost doubled the town's population. (Courtesy of Michael Slawinski.)

IMAGES
of America

EVANS AND ANGOLA

Cheryl Delano

ARCADIA
PUBLISHING

Published by Arcadia Publishing
Charleston SC, Chicago IL, Portsmouth NH, San Francisco CA

Printed in the United States of America

Library of Congress Catalog Card Number: 2008936585

For all general information contact Arcadia Publishing at:
Telephone 843-853-2070
Fax 843-853-0044
E-mail sales@arcadiapublishing.com
For customer service and orders:
Toll-Free 1-888-313-2665

Visit us on the Internet at www.arcadiapublishing.com

*To my family, present and past, who fostered my interest in genealogy
and brought me to the closer study of our local history.*

CONTENTS

ACKNOWLEDGMENTS

Thanks to every member of the Evans Historical Society. They have been extremely supportive during this project. Unless otherwise noted, the images in this book have come from their archives. Special thanks go to president Bill Haberer, who actually shared some of his prized postcard collections with me. Other people also sent images to me. I was not able to use everything I was given, but I certainly appreciate the willingness to help. I had to make choices, and if I left out your favorite photograph, I apologize. Although he passed away many years ago, I have to thank Donald Cook. He was the first historian for the town of Evans, and I made a lot of use of his research. So much information was available because of him. Thanks to Rebekah Collinsworth and Arcadia Publishing for putting their faith in me and allowing me to put this project together. I knew they were always there with help and support.

INTRODUCTION

The first settler in the territory to be known as the town of Evans was Joel Harvey, who arrived in 1804 and built his house at the mouth of Eighteen Mile Creek. As others followed, Harvey built an addition to be used as a hotel and named it the Frontier House.

The first permanent settler was Aaron Salisbury, who located about three miles from the Frontier House. In 1810, settlers moved farther south to the Evans Center area, and by 1812, William Cash had located in the southwestern section of the area.

The War of 1812 had little effect on the local residents, although they had to put up with raiding parties that visited chicken coops, pigpens, and potato bins. Occasionally, men were captured by the British, but they were usually released after a few days. Legend has it that Salisbury single-handedly scared away one of these raiding parties by hiding along the creek bank and firing random shots with his musket. He convinced the British that there was more than one person in the area, and they left rather than having a confrontation.

The only casualty of the war was Maj. William Dudley, the schoolmaster at the Evans Center School. He received orders to rejoin his regiment at Black Rock, dismissed his students, and rode to Buffalo. He was killed on December 30, 1813.

The end of the war gave impetus to settlers headed west, and the Holland Land Company began to rapidly sell acreage in the territory. Sawmills and gristmills were built, and frame buildings replaced log homes. Immigration to this lakeside area increased at such a rate that authorities began to see the need to separate from the town of Eden and create their own township. The New York State legislature accepted the petition, and the town of Evans was formed on March 31, 1821.

The area known as Wright's Mills became known as Evans Center and for many years was the metropolitan center of the township. Other small settlements were Pontiac, North Evans (Hobuck), and East Evans. Later years saw the development of Angola, Angola-on-the-Lake, Derby, Lake Erie Beach, and Highland. Chapter 1 will touch on each of the settlements, their development, and some of their history.

On February 22, 1852, the Buffalo and State Line Railroad opened for travel through the town. The village of Angola was quickly established near the railroad, as it provided for industrial development. Many buildings were moved from Evans Center, including the home of William Wright. Originally it was to be used as the new post office, but another building was chosen, and the home became the Angola Hotel.

The village of Angola is featured in chapter 2. This little settlement was first known as Evans Station, but John Andrus managed to find an abandoned post office named Angola and had it

moved to the emerging village. A majority of residents in the original Angola were Quakers who supported the African nation as one of their missionary projects, and the name was retained as the post office was moved.

The local economy was stimulated even further when major industries such as the Lyth Tile and Emblem Bicycle Companies brought their operations to the village. In 1908, the Buffalo and Lake Erie Traction Company opened its trolley line from Buffalo to Angola. Service through to Erie, Pennsylvania, was completed in 1909. This mode of transportation supplied service to the area for 25 years, bringing visitors to Angola and the summer camps that were growing in number, until the advent of the automobile and the beginning of the Depression saw it disappear from the American scene.

The town's location on Lake Erie helped further its development, even after the industries had left the area. Chapter 3 refers to the summer visitors who came at all ages and from all levels of society.

In 1875, Deacon Joseph Bennett, a longtime resident of the town, had a family come and camp on his land. Later that same summer, he took in his first boarders. The numbers continued to grow, a dining hall was added, cabins were built, and by 1885, they were able to accommodate 100 people at a time. His sons Seymour and Judson established camping facilities on either side and built hotels known as Bennett Park Villa and Pine Lodge, respectively.

In 1888, the Cradle Beach Camp (or Fresh Air Mission) was founded to provide fresh air and nourishment to the county's underprivileged children. Other camps that flourished were also supported by church groups, the YMCA, and private individuals. Developers bought up tracts of land and did everything to draw people to the area. It started with Grandview Bay and Lake Bay (Wigwam City) and was followed by the Home Guardian Company at Lake Erie Beach and places like Oakgrove and Shore Meadows.

The final group of summer visitors included some of the wealthiest families in the city of Buffalo. As lakefront property in the town of Hamburg sold, these families moved farther south and crossed the Eighteen Mile Creek into Evans. Names included Darwin Martin, who already owned one house designed by Frank Lloyd Wright and was about to own another; George Pierce of the Pierce Arrow Automobile Company; Edward Michael, a lawyer who once played leapfrog with Abraham Lincoln; and Spencer Kellogg, owner of a linseed oil company.

The final chapter is about some of the most memorable people and events in the town's history. The most famous resident is Willis H. Carrier. Born and raised in Evans, he graduated from Angola High School in 1894, went to Cornell University, and then on to work for Buffalo Forge Company. While there, he developed the process that led to the air-conditioning system and is known as the "Father of Air-Conditioning."

Other residents of note include, in art, a wood sculptor named Asa Ames; in politics, Pi Schwert, who also played baseball for the New York Yankees; in sports, Christian Laettner of Duke University and the NBA and Patrick Kaleta of the Buffalo Sabres in the NHL; and in entertainment, singers Clint Holmes and Marlene Ricci.

On December 18, 1867, there was a train disaster that became a national story. Named by the media as the "Angola Horror," there were numerous casualties, 19 of which remained unclaimed or unidentified. It has become known in recent years that John D. Rockefeller missed that train and survived to form Standard Oil.

Every town has its own personality and leaves its fingerprint on the area. These are some of the things that make Evans and Angola what it is today. Hopefully the images in *Evans and Angola* represent those factors and make history come to life for those who peruse its pages.

One

AROUND THE TOWN

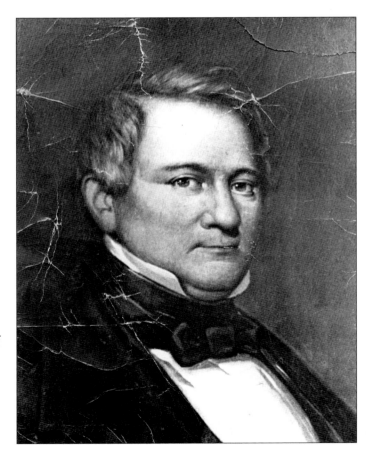

This is a portrait of David E. Evans, a clerk and later a resident agent for the Holland Land Company. He was known for his efficient and humane management of the company's settler clients and was popular with the pioneers. In March 1821 when the town was formed, it was named after him, and it became the town of Evans.

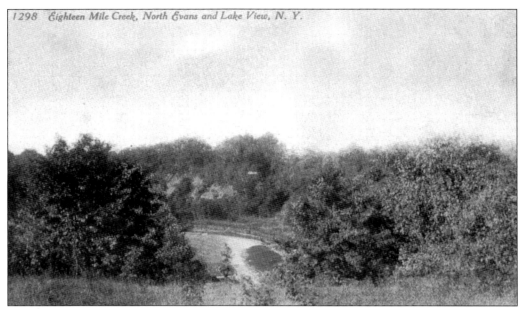

The Eighteen Mile Creek is the northern boundary of the town of Evans. Today it is quite shallow with high cliffs, but in the 1800s, it was navigable by large ships. During the War of 1812, the British were able to sail up the creek on raiding parties, and it was one of the major routes that settlers used as they moved west.

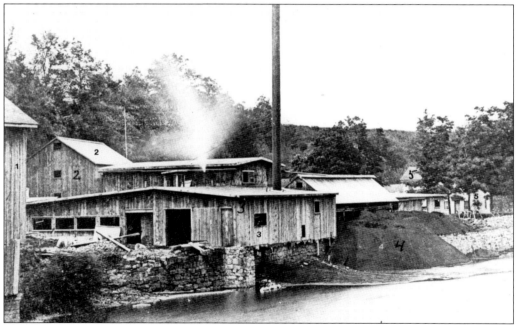

The creek was a logical place for sawmills and gristmills, and in the 1830s, the first of four tanneries was built. This is the third tannery around 1900 managed by Benjamin Brodie. He processed skins provided by locals but also received skins from all over the world. He once handled over 10,000 sea lion hides.

10

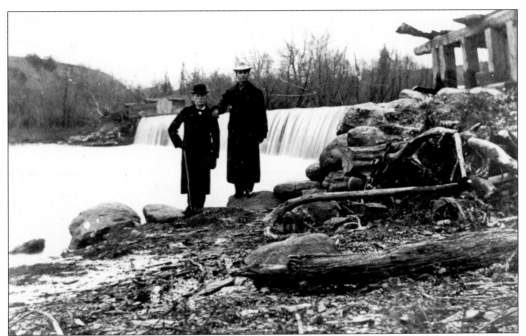

This is the dam on the Eighteen Mile Creek that supplied waterpower for the sawmill and flour mill. The gate in the upper right is what regulated the flow of water in the race to the mills. The two men are identified as Dick Frost and Ed Hummell, although nothing indicates who is who.

This photograph is dated 1900 and shows some of the workmen in the North Evans area. It shows the corner of Benjamin Brodie's tannery (1); the sawmill (2); the flour mill (3); and a storage building for the hides being treated at the tannery (4). There were several fires, but the complex finally closed for good after a flood in 1910.

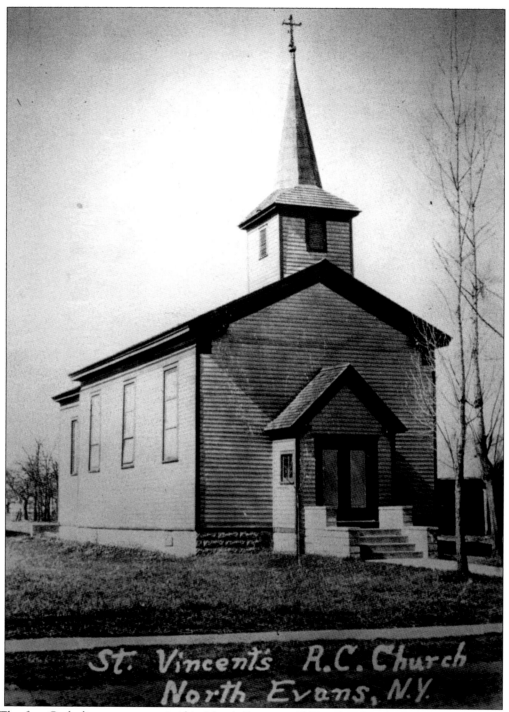

St. Vincent's R.C. Church
North Evans, N.Y.

The first Catholic masses were said in North Evans in 1845 and a church, St. Vincent de Paul, was built in 1853. This frame building burned in 1931 and was replaced by a brick one that served for a little over 30 years. A new octagonal church was built in 1969.

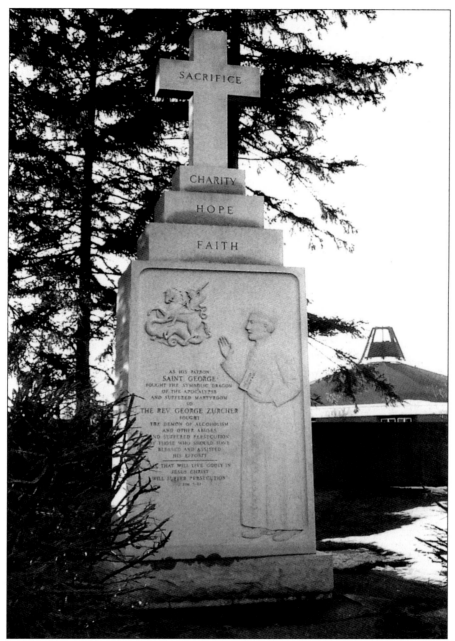

This is a fairly new monument dedicated to a little-known Catholic clergyman who was a voice for prohibition and temperance. Rev. George Zurcher was born in France in 1852. He studied at Niagara University, and after being ordained, he was sent to several churches in the area, including one in East Aurora. That is where he met Elbert Hubbard and helped publish temperance pamphlets. In 1914, he came to St. Vincent de Paul and spent the rest of his life in service there. The dedication on the monument reads, "As His Patron Saint George Fought the Symbolic Dragon of the Apocalypse . . . so the Rev. George Zurcher Fought the Demon of Alcoholism."

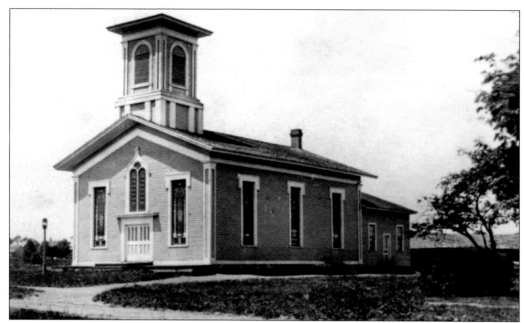

Notice the kerosene oil streetlight and the dirt roads in this 1900 picture of the North Evans Congregational Church. The church was formed in 1834 at the home of Deacon James Claghorn. The original building burned during the Civil War, and this one was constructed in 1863. In 1946, the church was raised and basement rooms were added.

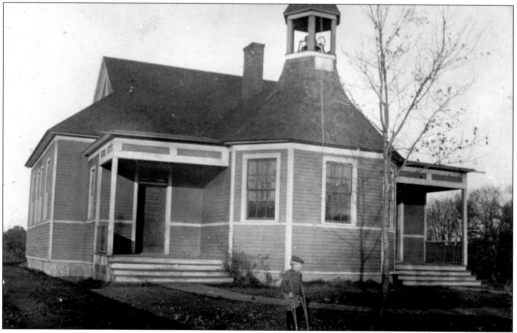

School No. 3, located on South Creek Road, was built in 1894 by George Ibach for a cost of $2,150. The location is now the site of a community swimming pool, and the school bell is on display at the Evans Historical Society.

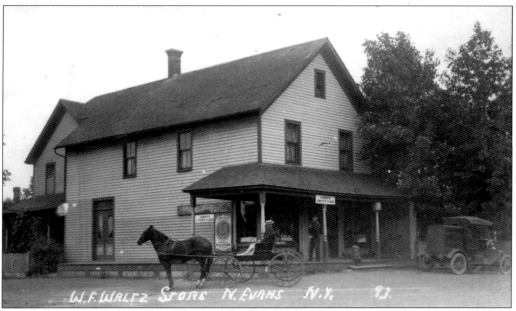

The store was originally built by Henry Bremer in 1895. He sold it to William Waltz, who was the owner when this picture was taken about 1914. The two men are identified as William (in the buggy) and Francis Waltz (on the porch). The store was later sold to George Hudak.

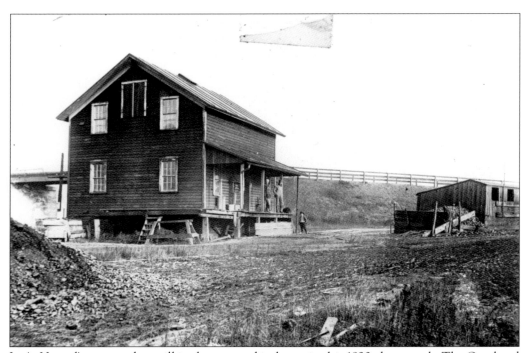

L. A. Hazard's was another mill in the area and is shown in this 1920 photograph. The Overhead Bridge can be seen behind the main building. The company is still in business today as a distributor of plumbing supplies.

The North Evans Hotel was built in 1858 by Henry Byron. At that time, the village was on a stagecoach route, and farmers were traveling from up to 20 miles away, bringing hides to the tannery and logs and grist to the mills. A dance hall was added in 1895.

This photograph was taken in front of the North Evans Hotel (1). John Swartz, the owner at the time, is one of the men holding the horse. The building (2) behind is a store that was later called the Lorenz house. There is a meat market (3) between Shepker's and the Charles Emmons store and post office.

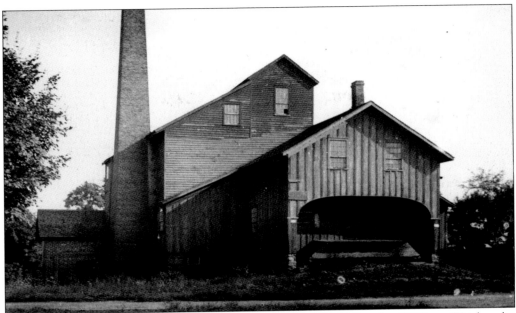

The area known as Evans Center was also called Wright's Mills after William Wright, the builder of the saw- and gristmills constructed along the Big Sister Creek. It was the policy of the Holland Land Company to give special consideration to those pioneers who agreed to build mills in suitable areas near waterways in order to stimulate community growth. Like the Eighteen Mile Creek, the Big Sister Creek was once much deeper and was able to support the mills here as well as the Bundy Mill in the village of Angola. Evans Center was the hub of the town for most of its early years. It had the first mills, post office, stores, and so on. The mill shown here is now a private residence.

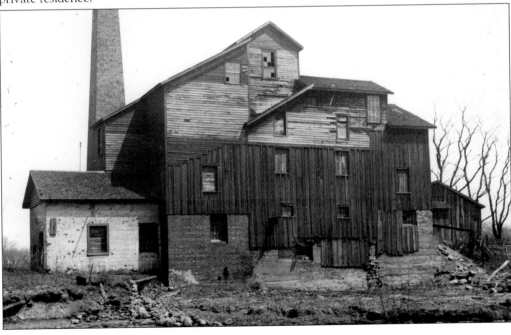

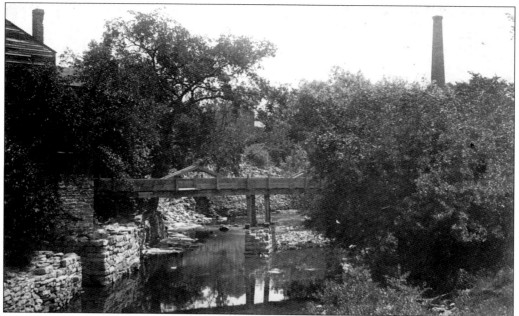

Also along Big Sister Creek was the Evans Center Tannery. This photograph, dated about 1880, was copied from an old tintype, and the image is reversed. The tannery was built by James Brodie, whose son Benjamin owned one in North Evans. The chimney in the background belongs to the gristmill.

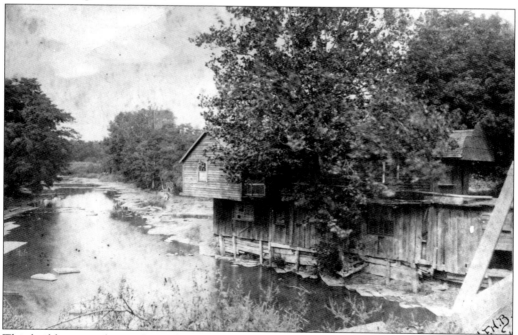

This building stands on what is known as Island No. 10, which was formed by Big Sister Creek and the race from the gristmill and tannery. There was a blacksmith shop and shoe shop on the ground floor and a family dwelling on the second floor.

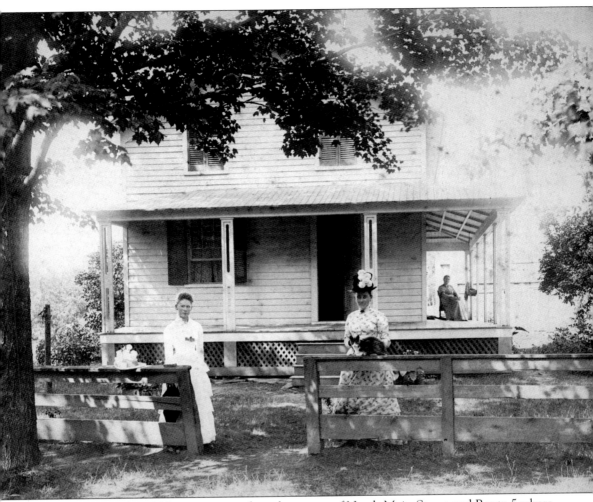

The home of Edward Hayes once stood on the corner of North Main Street and Route 5 where Catalano Motors is today. Taken between 1880 and 1885, the photograph shows what is typical of the early homes of the area. In the picture are Belle Hayes Backus (by the hat), Melvina Hayes Mix (near the cat), and Arabella Cole Hayes (wife of Edward Hayes) on the porch.

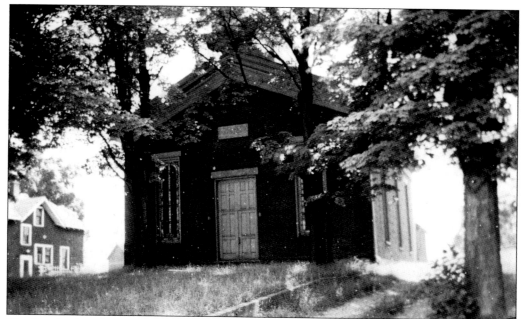

The Baptist church was organized on July 23, 1830, with Elder Jonathan Hascall as the first pastor. The first house of worship was a frame building on the present site on Church Road. In 1850, the first parsonage and barn were built. The present brick church was built in 1855. In recent years, the entrance was moved to the rear of the building, and the interior was completely renovated.

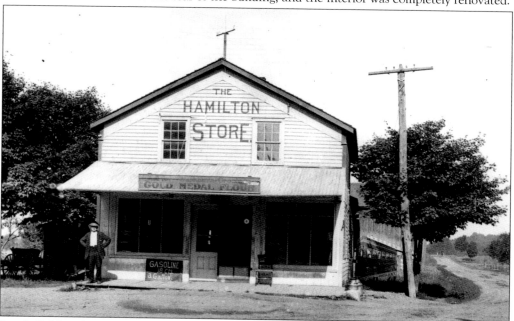

Josiah C. Hamilton is seen standing in front of his general store probably some time in the 1890s. It was located at the corner of Bennett and Erie Roads. From 1893 to 1897, he was the postmaster, and the Evans Center post office was located here. The business was next owned by the Riker family, who built a cement block structure and added gas pumps. Today it is a private residence.

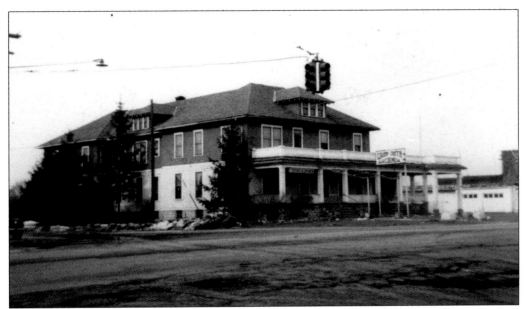

One of the earliest hotels between Evans and Buffalo was built in the early 1920s by Fred N. Boyer at the corner of Bennett and Erie Roads across from the Hamilton store. Following Boyer's death, the business was continued for awhile by his son Albert and later sold to Leroy Smith of Buffalo. It was known as Leroy Smith's Hacienda. The building was a nursing home for a period of time and is now offices for Claddagh.

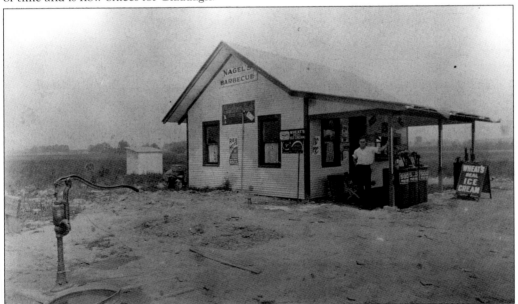

In the early 1900s, Fred "Pop" Nagel opened a small hot dog stand with gas pumps out front. As he became more successful, he expanded the business, and in 1932, he added four bowling alleys. He was known for his great soda fountain. When Nagel retired in 1946, Milt Tanner took over and featured Hungarian goulash. Then in 1953, it was sold to the Cicarelli family and became known as Chick's.

Also along Route 5 in Evans Center was Louis Kuntz's Candy Store. It was a restaurant as well but was known for the homemade candy. Today people remember the suckers and sponge candy made on the premises. After the store closed, the building was moved across the street and became a home. It is still recognizable due to the bay window just behind the fence in the picture.

This is North Main Street coming from the village of Angola and headed toward Gold Street. The picture was titled Tanner's Corners by the original photographer; however, the house straight ahead is probably the better known. The house was built just after the Civil War and was called the Harper-Ayer-Rose home, now the home of the Bluff family. The house to the right was the home of Frank and Addie Tanner.

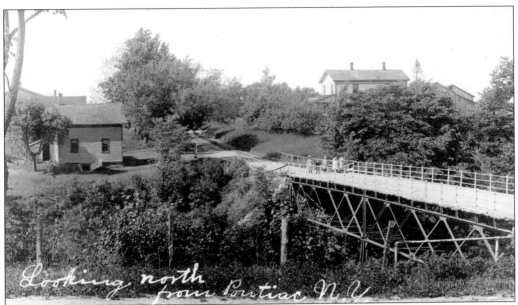

Looking north from Pontiac N.Y.

Pontiac was once a thriving community within the town of Evans located on the toll road between Buffalo and Gowanda. There were an amazing number of businesses there in the mid-1800s, including a blacksmith, a hotel, a wagon shop, a box factory, and a shoe store along with the usual mills and churches.

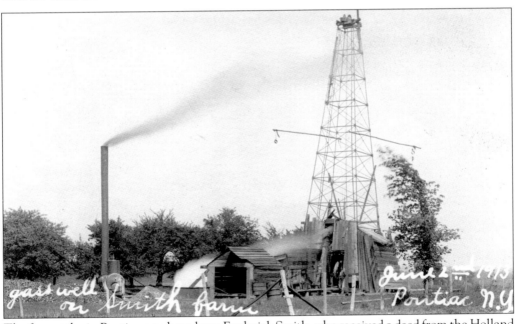

gas well on Smith farm June 2 — 1913 Pontiac N.Y.

The first settler in Pontiac may have been Frederick Smith, who received a deed from the Holland Land Company to build a mill along Big Sister Creek. The area was first called Smith Mills, but because it was the third settlement with such a name, it soon changed to Pontiac. This is a gas well on the Smith farm. Despite the many businesses, waterpower, and gas wells, the railroads drew business away from this area.

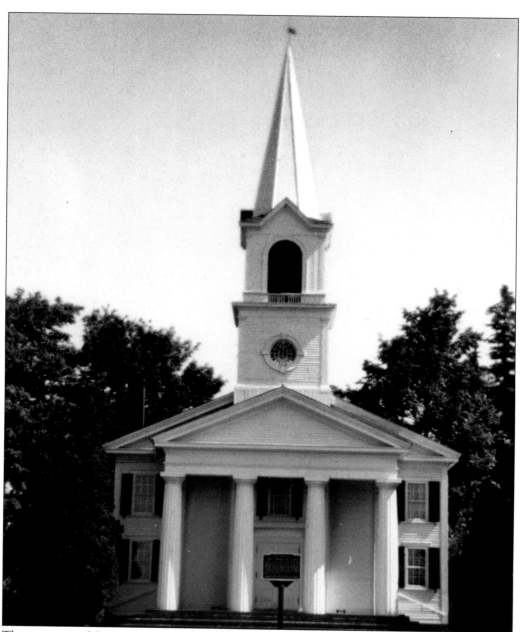

The area around Sturgeon Point Road, Erie Road (Route 5), and Sweetland Road was known as East Evans and later Jerusalem Corners. The First Church of Evans was located here. A log house of worship was replaced by a frame church built by Deacon James Claghorn, who also constructed the Congregational Church in North Evans. It was dedicated on December 11, 1835. Supposedly, a carpenter working on the belfry called the beautiful view "the new Jerusalem," which is where the name Jerusalem Corners came from. This church was completely destroyed by fire in 1914 but was rebuilt within a year. It was basically a reproduction of the original building inside and out with the pillars and a spire added. It has been one of the most photographed churches in the country over the years.

At the corner of Route 5 and Sweetland Road is the house that Dr. George Sweetland built in 1825. This picture was taken in 1921 when the house was sold. From left to right are Charles Clark, Roy Sweetland (who sold his grandfather's house), Allie Maeder, Tunis Clark, Andrew Clark, Gertrude Kellogg Clark, Mary Stull, Doris Kellogg (the buyer), Margaret Parke, and Duncan Pierce.

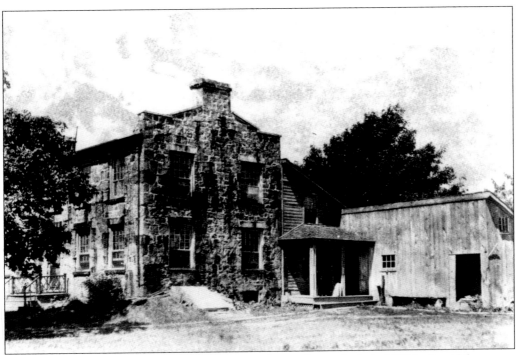

Another old home in the area is the Morseman house. It was built in 1835 by Levi Morseman using stones that were brought up from the bottom of the high bank along the Lake Erie shore. The barn was torn down in 1950, but the house still stands.

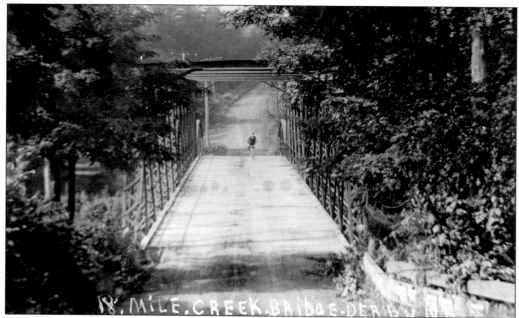

The main route along the lake was what is now known as the Old Lake Shore Road before Route 5 was extended. This is the bridge across the Eighteen Mile Creek connecting the town of Hamburg with the town of Evans in Derby.

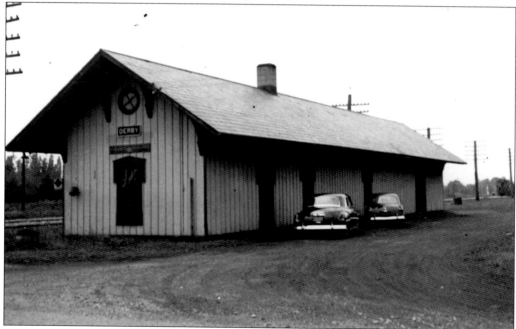

Area farmers donated cash to the railroad for a local station, and John Dibble donated the land. The company offered to name it Dibble, but he did not want that, so it was named after Henry G. Derby of Pennsylvania, an official of the railroad. The first Derby Post Office was located here from April 1873 to August 1876.

As some of the subdivisions opened in the town, there was a lack of roads to handle traffic problems. What is now known as the Old Lake Shore Road was the main route from East Evans northward, but the cutoff was built in 1933. This was a continuation of Route 5 from the point where it turned off at Sweetland Road to the Bayview area in Hamburg. It made the trip from Buffalo to Evans shorter and faster. These were realtors' signs advertising the lots in the subdivision called Highland-on-the-Lake. There eight roads crossed Route 5 and were open to new housing and business in that part of town.

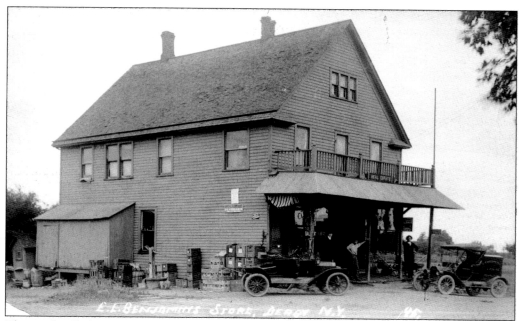

This is the Earl L. Benjamin store located in Derby. It was originally opened by Francis A. (Frank) Benjamin, a veteran of the Civil War. He and his son Fred H. were killed on May 2, 1907, at a railroad crossing while driving a covered delivery wagon. Earl was the other son who kept the store running.

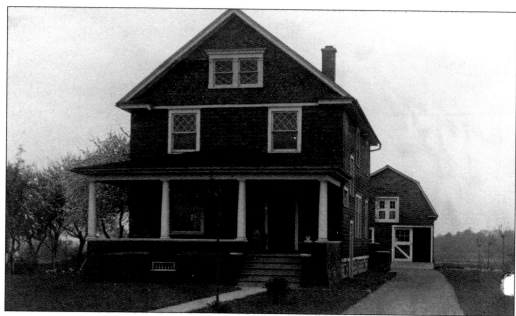

Frank Benjamin sold his original home to A. K. Brodie and had this one built on Derby Road. He was married to Maud Tucker, the sister of Elmer Tucker, a noted horse dealer and trainer.

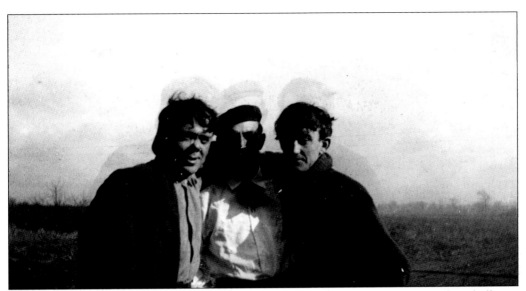

In November 1909, a group of hot-air balloons began a race in Cincinnati, Ohio. Three balloons were wrecked by a storm before the race even started. The balloon Haddock was blown twice across Lake Erie before it landed in a tree on the Valin farm in Derby. It actually landed in the dark, hit the house, and then bounced out to the tree. Two of the three men were thrown out before landing in the tree. They were all cut and bruised but alive. The three men below are newspapermen J. Campbell Cory and C. D. Travis and the pilot is George Howard.

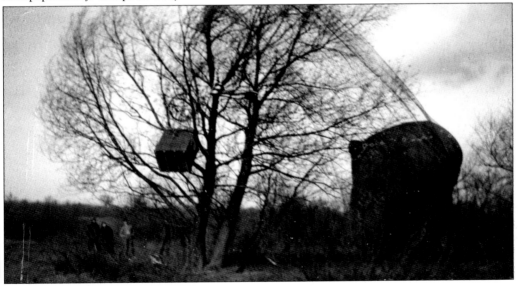

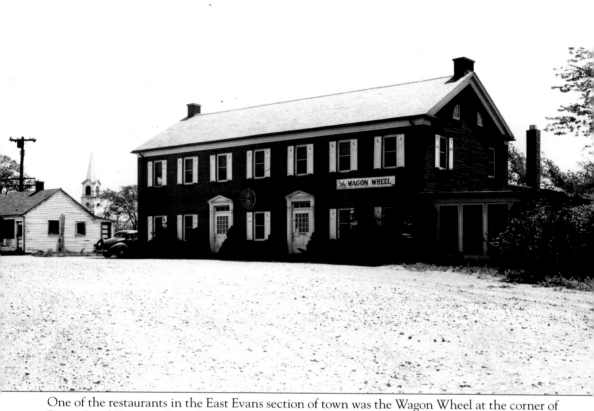

One of the restaurants in the East Evans section of town was the Wagon Wheel at the corner of Route 5 and Sturgeon Point Road. Owners and managers included Donald Cherry, Paul Peacock, Burt Lewis, and Sam Duff. It burned and was restored and used for office space. The spire in the background is from the First Church of Evans.

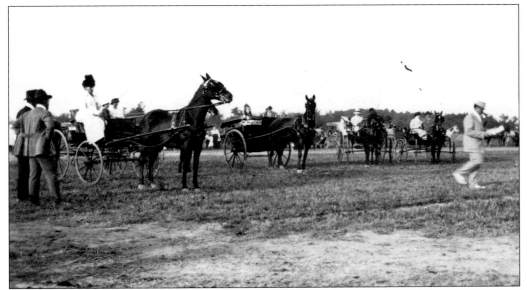

Many of the wealthier families who came to Evans in the summer were active in the world of polo, foxhunts, and horse shows. In the early 1900s, there were many horse shows in the Derby area, and some were part of the Derby Fair at the First Church of Evans. This is an early picture of a Derby horse show.

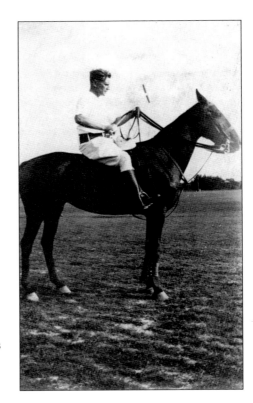

The Derby (or Lake Shore) Hunt Club also had a polo league in the 1920s. This is a photograph of Howard Kellogg on his polo pony. Other members included Stewart Mann, Frank Trubee Jr., and Walter Scmidt, who were all relatives of the families who summered in the town.

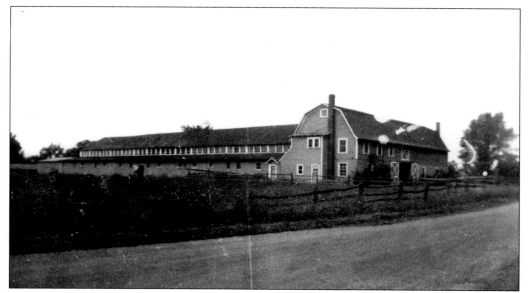

The Lake Shore Hunt Club (also referred to as the Derby Hunt Club) was established in the 1920s, and this stable was built on Delamater Road by Gary Dingman. It had a polo team and held foxhunts and horse shows. The property was sold in 1945, and the barn and acreage became a dairy farm owned by Willis Burke.

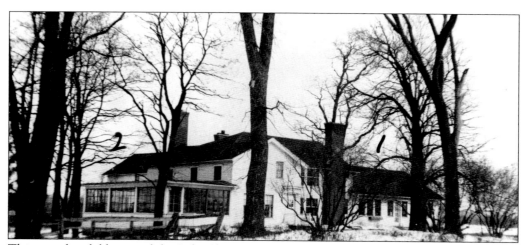

This was the clubhouse of the Lake Shore Hunt Club. After the club was disbanded and the property sold, the dining room (1) was moved by Burke to Burns Road and made into a house, and the kitchen (2) was moved by William Grupp to Backus Road where it also became a house.

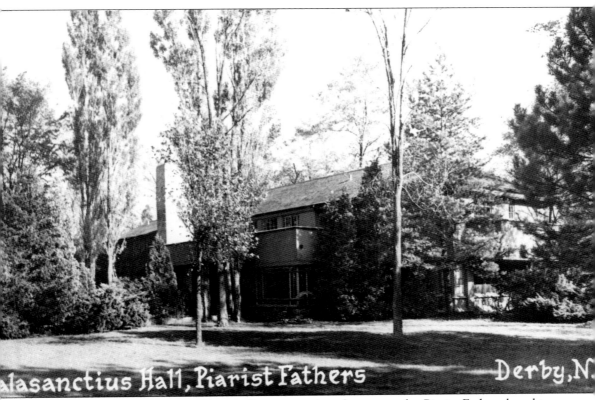

alasanctius Hall, Piarist Fathers — Derby, N.

In the early 1950s, a group of Eastern European priests known as the Piarist Fathers bought property in the town. They provided a safe haven for refugees, particularly from Hungary, taught them English, and found them jobs. Students first attended St. Francis High School while living there but later schooling was offered on the grounds. They also established Calasanctius High School in the city of Buffalo. The house was originally designed by Frank Lloyd Wright and was the summer home of Darwin and Isabel Martin. When the order of priests became too small to support the property, it was sold to a group called the Graycliff Conservancy that is in the process of restoring the house and grounds.

Cliffs Along Lake Erie

At the other end of the town, there are more high cliffs along the lakeshore. They were originally called Cash's High Banks after the family that first settled the area. It became the Shore Meadows Subdivision around 1929 when Ward Cash opened the land for settlement.

Iroquois Beach, Angola, N. Y.

12334.

Iroquois Beach is the name for the section along what is known as the Lake Bay area. Evans is known for its beaches and shoreline. That is the main reason it became known for its camps and vacation places, and there are many postcards such as this one.

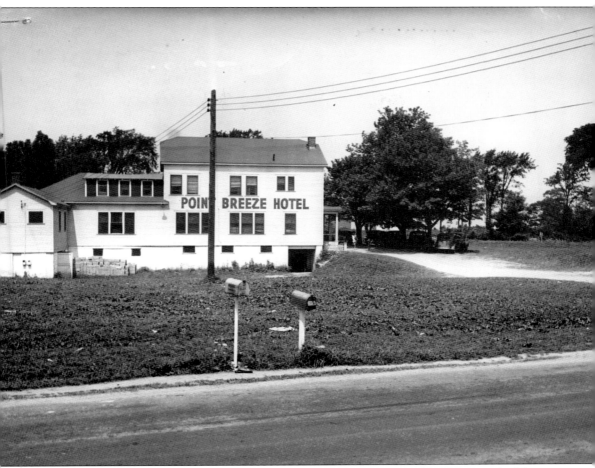

The Point Breeze Hotel was built in 1890 when the wealthier citizens of Buffalo were building summer homes in Buffalo and steamships brought vacationers to the area. It became a prominent spot during Prohibition, probably one of the sites for the period's rumrunners, and it survived the Depression until it became popular again in the 1950s with the influx of the college crowd in the town of Evans. Under the ownership of the Nowak family, it had become a seasonal restaurant known for its fish fries and "beach polka parties." It burned on February 5, 1992. (Courtesy of Mike Slawinski.)

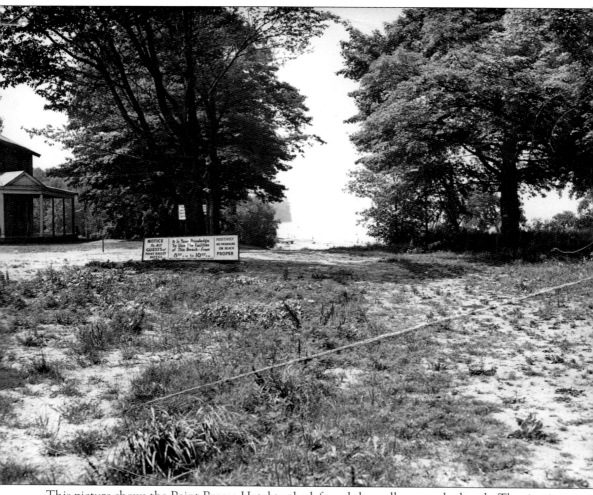

This picture shows the Point Breeze Hotel to the left and the walkway to the beach. The sign is difficult to read, but under the section giving the privilege to use the beach is a notice that reads, "Positively no changing clothes in cars." (Courtesy of Mike Slawinski.)

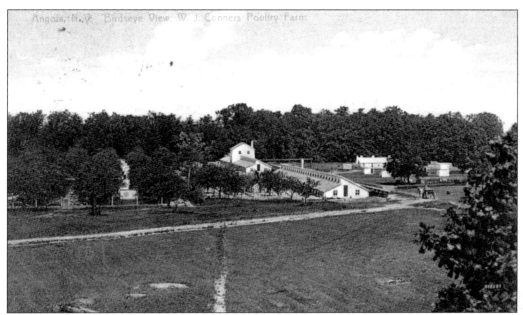

One of the businesses along Lake Erie at Angola-on-the-Lake was the William J. Connors poultry farm. It was said that it was "the largest, most modern and most thoroughly equipped plant for the production of eggs and poultry in the World." The plant was started on August 7, 1907, by Connors, who was the owner of the *Buffalo Courier*. There were 258 buildings on 360 acres of land. They included 19 laying houses, five brooding houses, 108 colony houses, and four dwellings for the manager and his staff among others. The postcard below shows a barn (1), the water tower that held 50,000 gallons of water (2), laying houses (3), the incubator house (4), and the big farm house where the manager William J. Hurley lived (5). The Old Lake Shore Road runs between the laying houses and the incubator house.

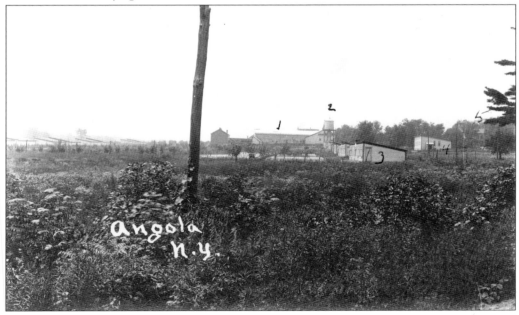

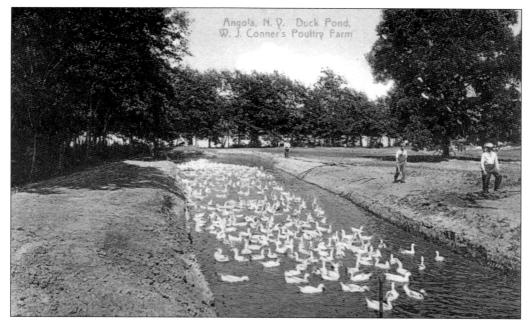

Ducks were an important product of the Connors poultry farm. White Pekin duck was sold to restaurants in the area by the thousands. This duck pond was artificial, and water was pumped from the lake. It soon became contaminated and was filled, so ducks were driven to the lake to swim.

The area of the poultry farm was taken by the Evans Land Corporation in 1921, and it became known as the Grandview Bay area. This building, the incubator house, became the Grandview Bay Community House when the area was developed and lots were sold. The Grandview Bay Community Association was formed in 1925 and sponsored dances, recitals, and carnivals for the residents.

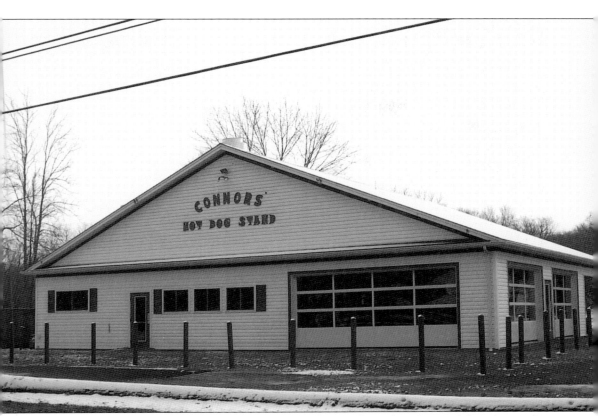

Connors' Hot Dog Stand is a family-run restaurant known for its hot dogs and fries, but it also serves burgers, chicken sandwiches, and other summer fare. It was opened in 1944 by Thomas Connors and is now in its third generation. Working at the hot dog stand has been a rite of passage in the family, as each generation of teenagers works at the restaurant in the summer. According to a recent news article, on a typical summer day, they serve 500 pounds of potatoes and 600 pounds of hot dogs. The numbers may be even higher now. There are outdoor tables only; patrons must go inside to order and carry food to one of the picnic tables. Around 2001, the Connors family tore down the existing building and built a new restaurant without changing the ambience. It is the one shown here.

Across the street from the Evans Town Park and just down the road from Connors' Hot Dog Stand is this view. Angola-on-the-Lake was the place to be in the 1950s and 1960s for anyone over 18 (the legal drinking age then). In 1962, the Angola/Point Breeze area was named as one of the top five vacation places in New York State. The building on the left is now Captain Kidds', but it was once the location of Lerczak's Log Cabin, known far and wide. It was later the location for the WMU (Western Michigan University) Club. Next door is the South Shore Inn. Along with Bill Miller's Riviera, the Du Drop Inn, Lake Lodge, Point Breeze Hotel, and Castaways, these were the favorite destinations of locals and visitors alike.

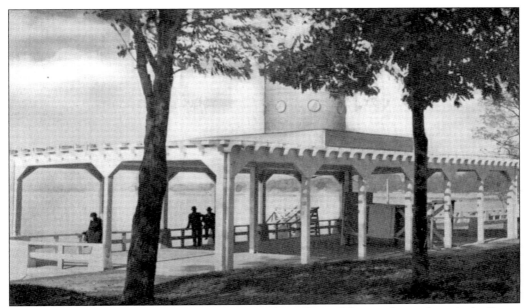

There are a number of local, county, and state parks in Evans. The one for residents is the Evans Town Park just down the road from Connors'. In order to get a sticker allowing entry, all that is needed is proof of residency. Walking from the ball fields and picnic area, one can go under the road through a tunnel and holler to hear voices echo. At one time, this pavilion was ahead, looking out over the lake and its sandy beach. (Courtesy of Bill Haberer.)

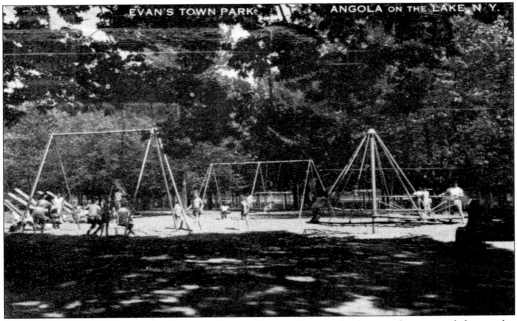

Like most parks, there was a playground near the pavilion with the usual swings, slides, and a merry-go-round. If someone fell off, they landed in the sand rather than on hard ground.

41

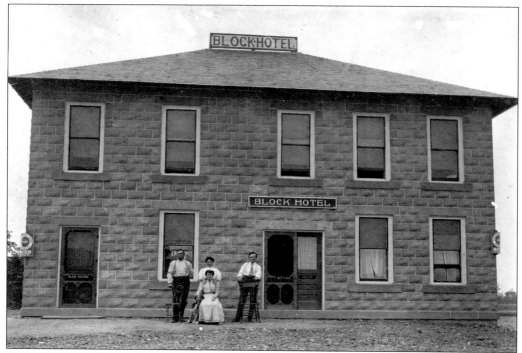

Until just recently, the Block Hotel was at the corner of Lake Street and Route 5. When it was built in 1905, Charles and Mary Rogendorf used a new technique that created square and rectangular blocks from stone and concrete. Built as a way station between Buffalo and Erie, Pennsylvania, the Block Hotel had sleeping rooms, a dining room, and stable services.

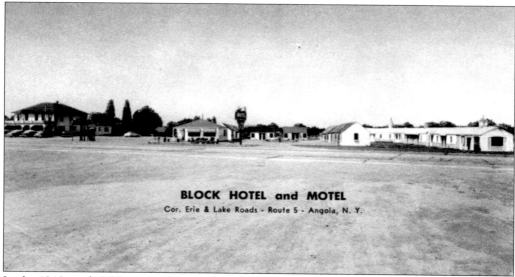

In the 1940s and 1950s, a motel was built with all the amenities, including a swimming pool and access to the restaurant next door. It was called the Block Hotel and Motel and was particularly busy when the summer visitors started to arrive. The hotel was taken down in August 2008, and the motel will probably soon follow. (Courtesy of Bill Haberer.)

Two

THE VILLAGE OF ANGOLA

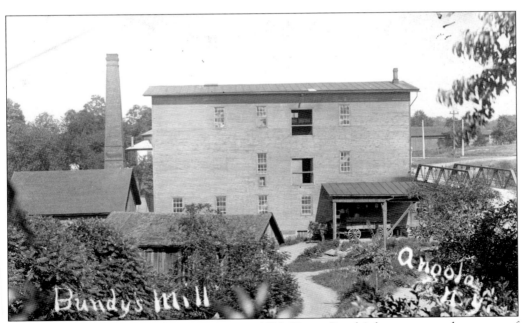

The Bundy family came to the Evans area in 1830. Henry Bundy's home was at the corner of Orchard and Mill Streets. The Angola Steam and Water Power Flour Mill along Big Sister Creek on Mill Street was operated by his three sons. The business was extended by adding a planning mill and a sash, blind, and door factory in the 1860s.

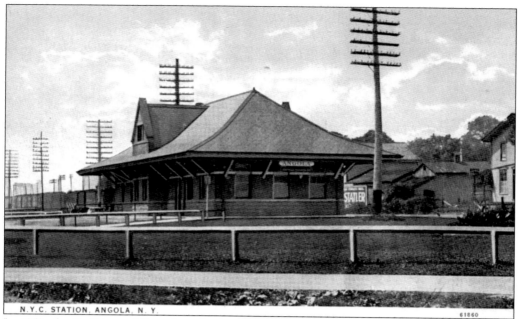

N.Y.C. STATION, ANGOLA, N. Y. 61860

In 1852, the Buffalo and State Line Railroad laid tracks and built a train station about a mile south of Evans Center, causing a shift in activity and population. Originally called Evans Station, the village became known as Angola when John Andrus found an abandoned post office near Gowanda and petitioned to have it transferred here. The majority of residents there had supported missionaries in the African nation of Angola and named their settlement after it. The name remained with the post office. This is not the original depot but one that was built later. The picture below shows supplies destined for the Connors poultry farm in front of the depot, ready for delivery.

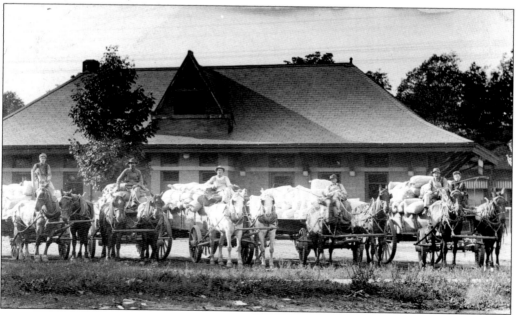

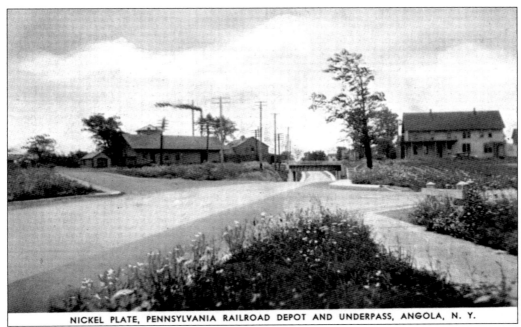

NICKEL PLATE, PENNSYLVANIA RAILROAD DEPOT AND UNDERPASS, ANGOLA, N. Y.

In 1880, the Buffalo, Pittsburgh and Western Railroad was organized and, along with the Nickel Plate Road, built a connection from Buffalo to Brocton. The Nickel Plate Road built this station in 1882. It served the Bison Canning Company along with other businesses. This passenger and freight station was used in Evans and Angola well into the 1950s. Recently, a group known as the Angola Depot Preservation Society saved the depot from destruction and had it moved with hopes of finding a use for it. The close-up view of the station shows a large package waiting to be picked up. An Emblem bicycle is waiting to be shipped.

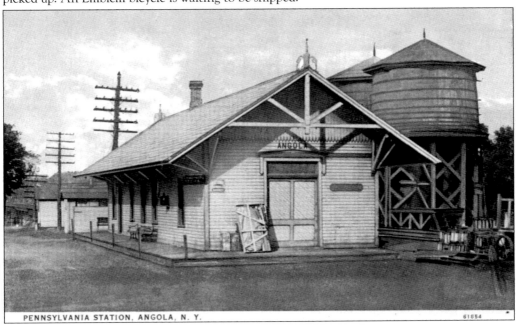

PENNSYLVANIA STATION, ANGOLA, N. Y. 61854

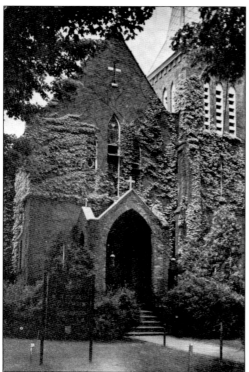

In 1854, a school was built on Lake Street in the village, but by 1870, its registration had increased far beyond its capacity. The building was occupied in 1871 by the newly formed Most Precious Blood Roman Catholic Church. The building became run down and it was decided to erect a structure that would be an "ornament" to the town and a credit to the Catholics. This building was dedicated in 1894. Today it is a private residence.

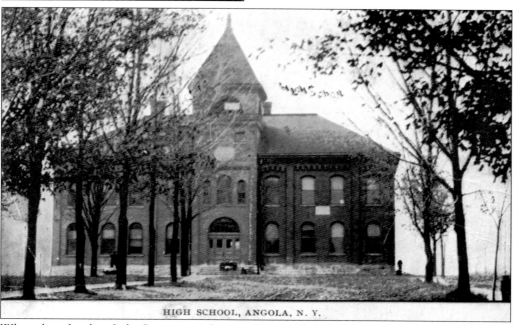

HIGH SCHOOL., ANGOLA, N. Y.

When the school on Lake Street was taken over by the Catholics, the village trustees purchased a parcel of land on High Street. The 1870 structure was known as the Angola Academy and Union School. The building has seen many changes and additions and is still operated as the J. T. Waugh School in the Lake Shore Central School District.

When the population shifted with the coming of the railroad, the parishioners of the First Church of Evans needed religious services closer to their homes. Early in 1863, a church was formed and met for awhile in the Andrus store. This building, the First Congregational Church, was dedicated in 1865 and was totally destroyed by fire on October 11, 1968.

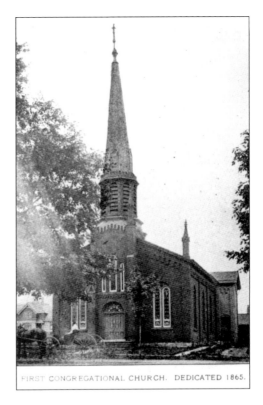

FIRST CONGREGATIONAL CHURCH. DEDICATED 1865.

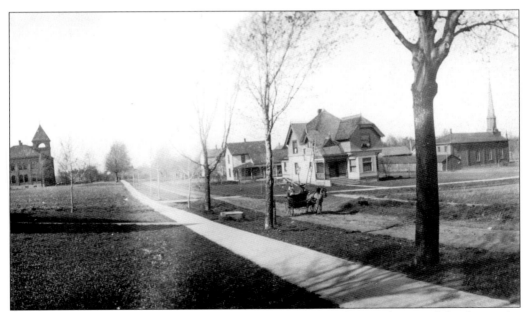

This photograph shows High Street facing north. Angola Academy and Union School is on the left, and the First Congregational Church is to the right.

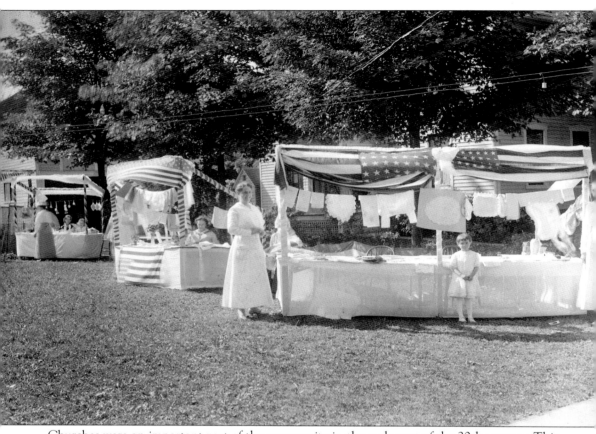

Churches were an important part of the community in the early part of the 20th century. This picture was taken at a lawn fete at the Congregational church in 1918.

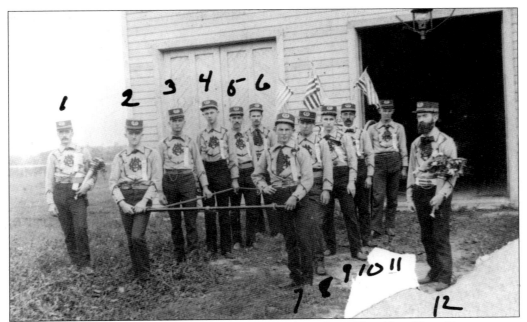

Fire was always a fear for residents of the town and the village. The Alert Hose Company was organized on May 28, 1865. From left to right are A. W. Candee, E. H. Parker, C. Cash, L. Flint, A. J. Wassman, H. S. Landon, Eber Kelly, F. Nevins, W. M. Landon, F. Sweetland, J. Stone, and W. B. Sweet.

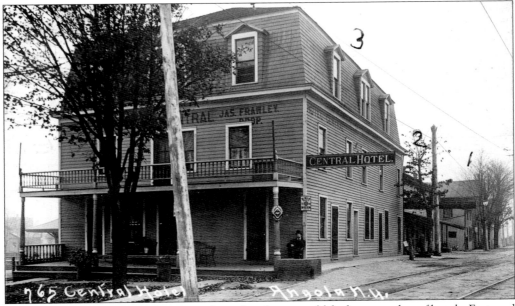

Along Commercial Street adjacent to the railroad, one could find any number of hotels. Featured is the Central Hotel, but behind it are the Angola Hotel and the Railroad House. Over the years, the Central Hotel was a store, a post office, and a hotel under several owners. At the time of this photograph, it was owned by James Frawley, who added the third story and was also shot here in 1908. His widow continued to run the hotel.

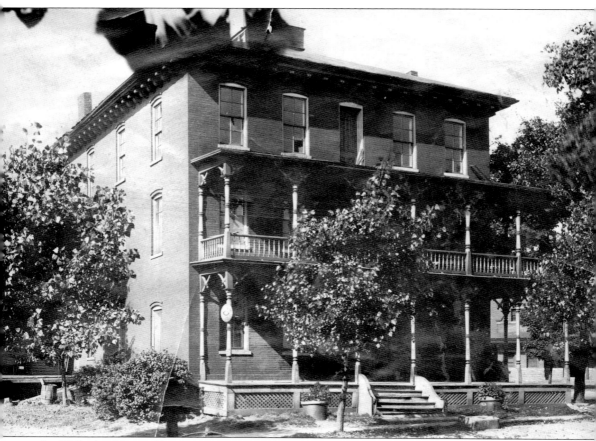

In 1877, the Union Hotel was constructed on South Main Street by George Caskey. Other owners included E. P. Smith and A. J. Watt, who also ran a livery stable that provided a place for travelers' horses. The building later became the Odd Fellows hall.

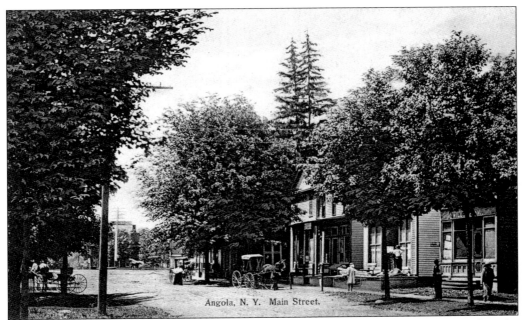

Angola, N. Y. Main Street.

These are two pictures of Main Street from around 1900. The roads were not yet paved, and a horse and buggy or bicycle seemed to be the best mode of transportation. Commercial Street was the major business area with its hotels and businesses. The photograph below shows what seems to be a parade of some sort, and the business in the background has been identified as Froehley's store and Funeral Home. Joseph Froehley made furniture and coffins for his customers.

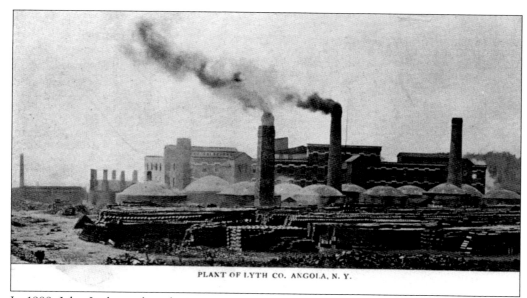

PLANT OF LYTH CO. ANGOLA, N. Y.

In 1888, John Lyth purchased 40 acres of land from J. R. Newton. It was located off Railroad Avenue adjacent to the tracks. There he built a plant to manufacture sewer pipes, hollow bricks, and tile. Known as John Lyth and Son, it operated until the mid-1920s. Clay could be excavated on the property, and there were several large ponds on the site. The picture below shows a close-up of one of the ovens or kilns that can be seen in large numbers in the first photograph. Today, more than 80 years since the factory's close, one can still find pieces of broken tile like those piled to the left below.

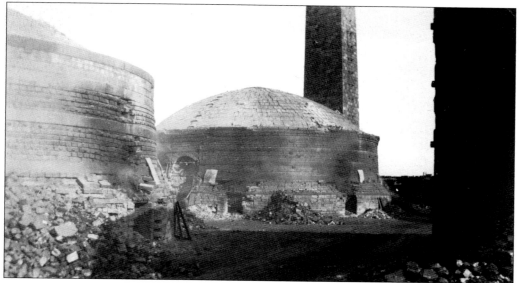

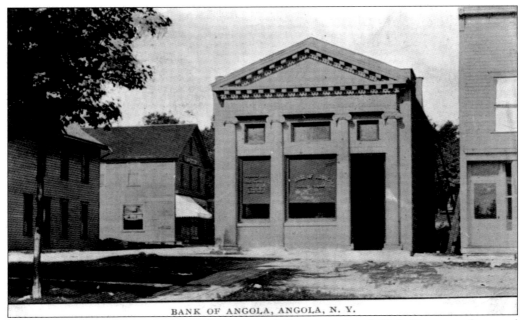

BANK OF ANGOLA, ANGOLA, N. Y.

The Bank of Angola was built on the corner of Commercial and High Streets and opened on June 1, 1906. At the close of the first day of business, deposits totaled $3,500. In 1925, a Westminster Chime Clock was placed on the front of the bank to let everyone in the vicinity know the time.

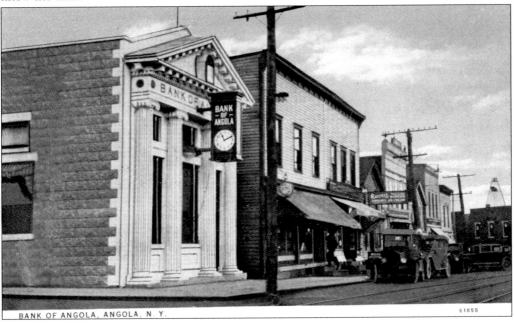

BANK OF ANGOLA, ANGOLA, N. Y. 61855

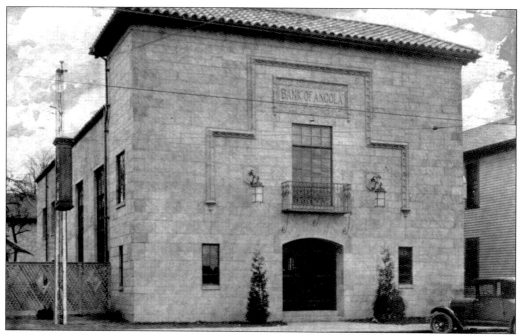

In 1927, the Bank of Angola decided to relocate to a new building on North Main Street. The building it vacated became the town hall and later the Angola Public Library. Due to the Depression, the Bank of Angola was forced to close in 1931. It attempted to reopen but failed.

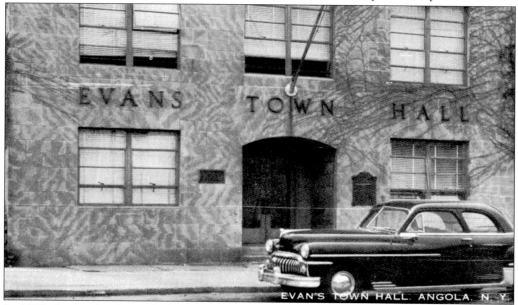

In 1935, the Bank of Angola building was turned into a market arcade with numerous stores under one roof, including a meat market, a grocery, a bakery, an ice-cream shop, a candy store, and an electrical appliance store. After the businesses relocated, it remained vacant for several years. After World War II, the town purchased and renovated the building to be used as the new town hall.

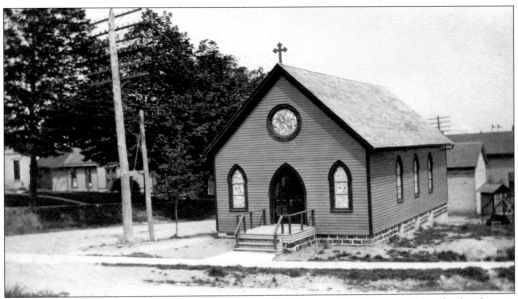

Soon after the Bank of Angola opened, the St. Paul Episcopal Mission purchased a lot from it on the corner of Lake and High Streets. The original cost was $365. Ground was broken in July 1909, and work was completed with the laying of the cornerstone in October 1911. It served the community for almost a century at this location and recently built and moved to a new church at the other end of Lake Street.

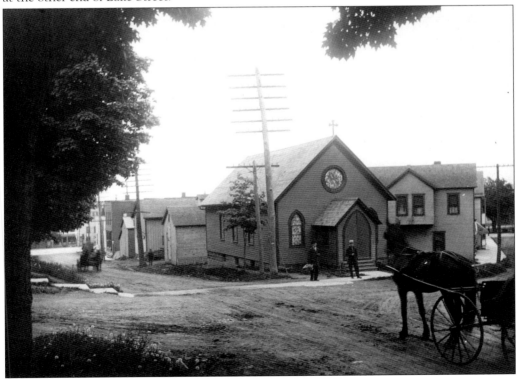

The Star Theatre opened around 1914, although movies were shown prior to this at the village hall. The owners and operators were Frank and Bessie Wiatrowski. Frank ran the projector, and his wife, Bessie, sold the tickets. Mamie, Frank's sister, played the piano to accompany the silent films. There was no screen, just a white, rectangular patch painted on the rear wall. Benches were the prevalent seating. It was nothing like the stadium seating of today. Admission was 10¢; for the matinee, it was only a nickel.

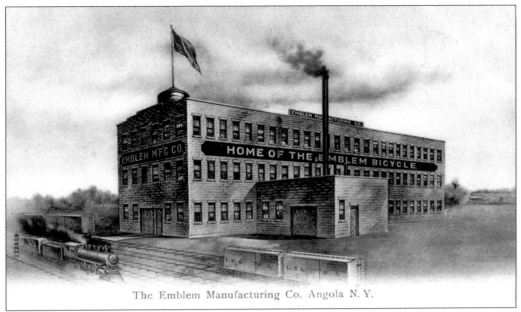

The Emblem Manufacturing Co. Angola N.Y.

In 1904, the Emblem Manufacturing Company bicycle factory transferred its headquarters from the north of town to the corner of South Main and York Streets. In 1908, a three-story cement block building was constructed with two additional stories added later. The company's bicycles and motorcycles were noted for their excellent quality. At one time, production reached 125 to 150 bicycles a day.

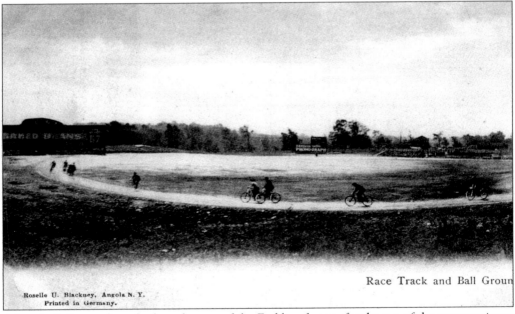

Race Track and Ball Groun

Roselle U. Blackney, Angola N. Y.
Printed in Germany.

A baseball diamond was built at the rear of the Emblem factory for the use of the community as well as the Emblem Baseball Club. A large circular track surrounded the ball field and was used for road testing the bicycles and motorcycles. A large grandstand could accommodate spectators for the games held here.

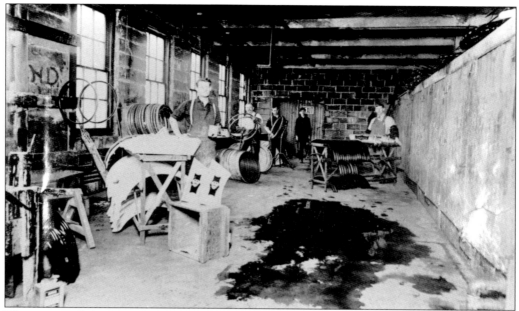

This is one of the various workrooms and assembly rooms at the Emblem factory. Hundreds of local men found work here, and there was constant expansion in the early 1900s, but the automobile, the Depression, and other economic factors led to the closing of the factory in the late 1930s. During World War II, the building became a branch factory of the Columbus McKinnon Chain Corp.

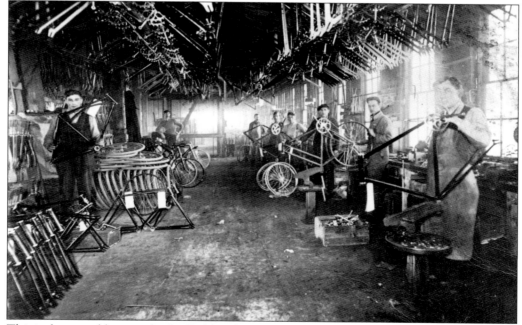

This is the assembly room for the Emblem bicycle factory, probably in 1911 or 1912. The workers are, from left to right, Leo Bedaske, Leo Conrad, Charles Blanca, Everett Spittler, Harry Stocker, Frank Green, Percy Hoover, and Albert (Bot) Spittler.

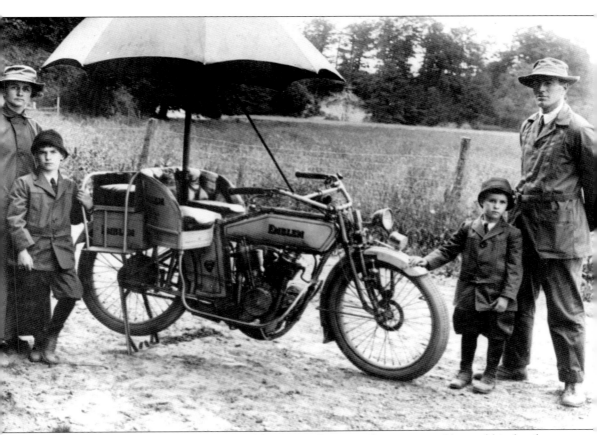

Maurice Gale was a test pilot for the Emblem Manufacturing Company, and he and his family were well known throughout the town. They were often seen riding this vehicle. They actually drove it all the way to California and part way home again. There was a two-passenger front seat for Gale and his wife plus two sidesaddle seats for their sons Edwin and Herbert. The most ingenious accessory has to be the umbrella. It seems it would be practical rain or shine. In 1916, the same family completed a transcontinental trip on motorcycles, towing a small covered wagon with advertising on it.

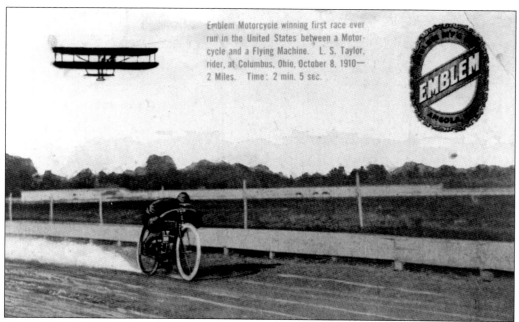

Emblem Motorcycle winning first race ever run in the United States between a Motorcycle and a Flying Machine. L. S. Taylor, rider, at Columbus, Ohio, October 8, 1910— 2 Miles. Time: 2 min. 5 sec.

On October 8, 1910, a race was held in Columbus, Ohio, between an Emblem motorcycle and an airplane. With L. S. Taylor riding, the motorcycle won, covering two miles in two minutes and five seconds. Two professional riders were killed while racing Emblem bikes, but the reputation of the bikes grew. Many were made for the military during World War I.

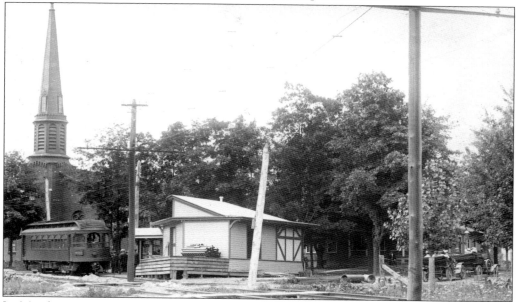

In March 1903, the Buffalo and Lake Erie Traction Company was granted a franchise, and regular trolley service began in 1908. The tracks followed Main Street from School Street to Commercial Street. The trolley station shown here was built at the corner of Main and School Streets in 1912. Passenger service was available every 40 minutes. It was just another mode of transportation to bring visitors and new residents to the area.

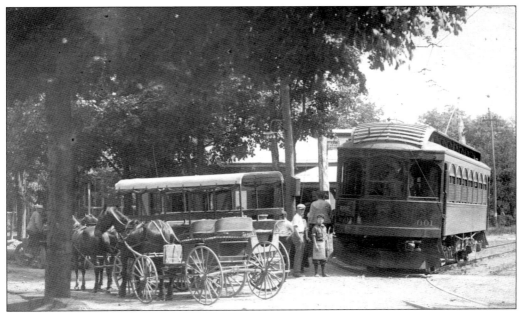

This photograph, taken in 1910, shows trolley No. 601 arriving in Angola on a summer day. The Alonson Wilcox wagonette in the back is waiting for fares to the lake camps. Notice the rolled-up side curtains that could be lowered in case of rain. There is also a smaller sunny weather rig in the foreground.

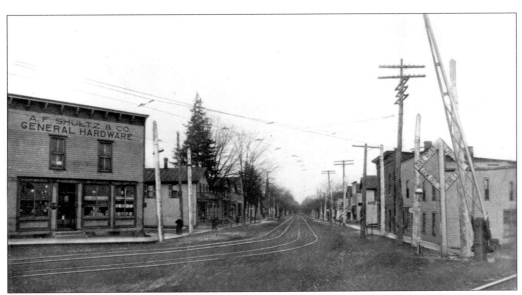

Looking north from the railroad tracks, one can get an excellent view of the trolley route as it turns the corner from Commercial Street and heads through town. A. F. Schulz and Company General Hardware is also visible.

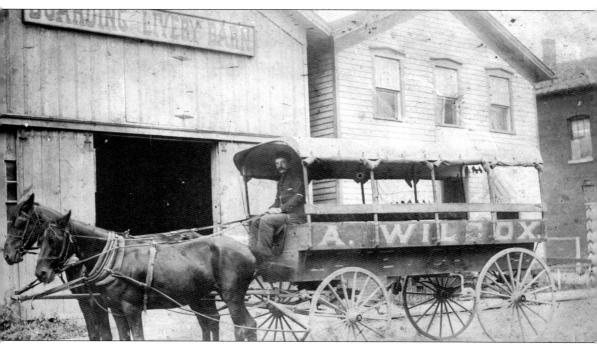

This is a close-up of the wagon on the previous page. The driver is Horace Camp, and this was labeled "the first bus to the lake." The village of Angola was two to three miles from the nearest park or camp at the lake. Transportation was needed to get the summer visitors to their destinations. Many of the camps had their own transportation, but others relied on the bus service. Notice that the side curtains could be lowered if it rained, and the one in the back section has been lowered already.

At the foot of Lake Street was a building used as a village hall. It can be seen in the picture on page 61 with a plain facade. In 1915, it was decided to add a balcony to the building. The main purpose was to provide the Angola Fire Department an opportunity to perform weekly Saturday night band concerts.

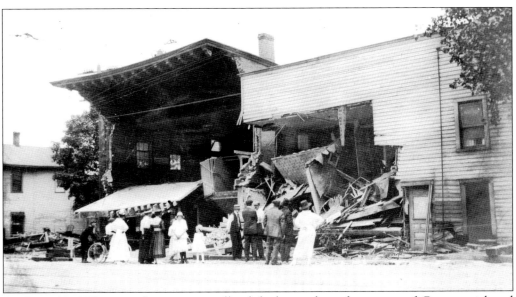

On June 19, 1918, an early-morning trolley left the track at the corner of Commercial and Main Streets. It rammed into Mrs. Neubeck's store, demolishing the northwest corner, and it continued through the front of the village hall. The firemen had to cut a hole to get the fire apparatus out because the entrance was blocked.

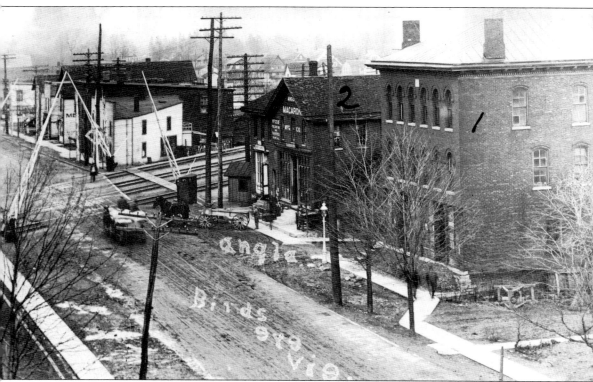

Building 1 in this photograph was built by E. G. Tifft in 1872. There was a general store on the ground floor, a residence on the second floor, and a hall used by several fraternal organizations on the third floor. Various other businesses occupied the building, including a lock factory, Pickering Vanilla Company, and a grape juice company. In the 1930s, the vacant building was purchased and demolished. Building 2 was actually the first one built by the Tifft family in 1866, probably the oldest brick building in the village. After the Tiffts moved to their new building, this one also housed many different businesses and for many years was the home of the Angola Macaroni Manufacturing Company. It has been a feed store and a carpet store and is well into its second century of use.

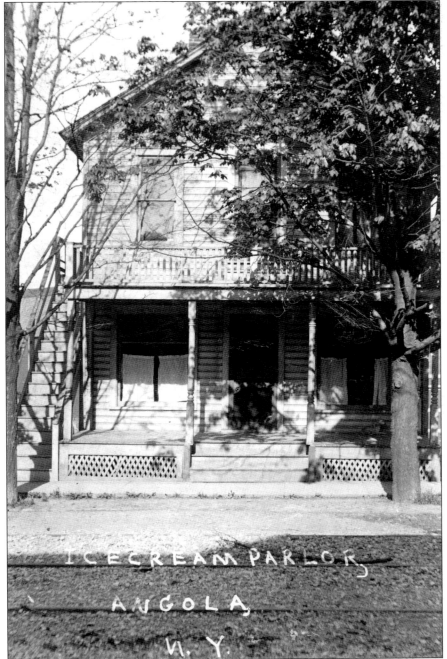

ICE CREAM PARLOR
ANGOLA
N. Y.

One of the most popular businesses in the village was the ice-cream parlor. This one was operated by sisters Belle Laverty and Sarah (Laverty) Dibble, widow of Orange Dibble. There was the usual soda fountain where sodas and sundaes were a nickel. There were even several miniature tables and chairs for the younger customers. Competition finally put them out of business, as Blackney's drugstore, Moses Jacobson's candy store, and "Auntie" Weston's opened their doors. The building became the Riehl Shoe Store and many years later was Matteson's Footwear Shop.

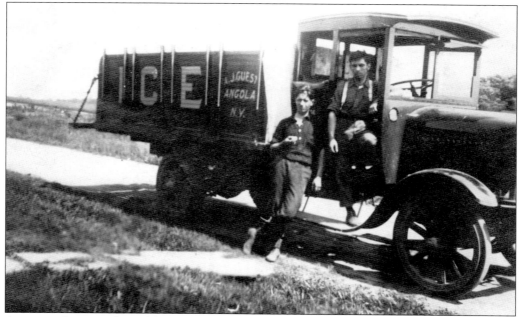

A partnership was formed between A. J. Guest and Lawrence Brown, and an ice plant was constructed on Center Street. They turned out the first cakes of ice in 1923. A water service was added to fill wells and later swimming pools. In 1954, Guest also purchased the *Angola Penny Saver* from Floyd House and joined his son Elwyn's *Evans Journal* office at the Center Street location.

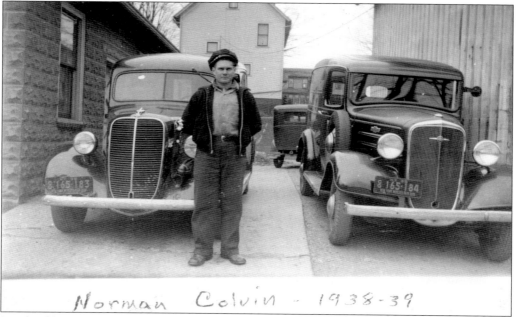

Norman Colvin - 1938-39

Frank Sibley established a dairy on Center Street in 1929 and relocated to the newly constructed quarters on Park Street in 1933. It continued in the same location until the late 1960s. Norm Colvin was one of the deliverymen in the 1930s, shown here with a couple of the trucks. The block building that housed the dairy can be seen to the left.

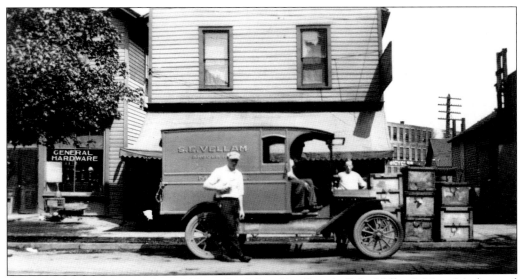

A new building was erected in 1925 north of the old village hall for Vellam's Meat Market and Ahr's Tire Shop. At this time, delivery was common, and this truck was seen around the village bringing food for evening meals.

There were many barbershops in the village over the years. The gentleman is unidentified, but the photograph is representative of the shops in the 1920s and 1930s, although it may be a little cleaner and neater than the majority.

Charles Paul's Hardware Store on the corner of Commercial and Main Streets was purchased by A. F. Schultz in 1881. The original wooden building dated back to 1861. That was later moved and used for storage when the current store was built. In 1926, a three-story brick building was constructed on the old site. Based on the flowers, this picture may have been taken at its grand opening. On the right are the familiar stairs to the second floor and the wooden floor that is still there. The store recently left family hands but is now competently run by Phil VanKoughnet.

An election in 1910 authorized the village to establish a water system at a cost not to exceed $55,000. In 1911, the foundation for a 100-foot-tall, 18-foot-diameter standpipe was completed. Notice the wagon wheels that were hoisted to the top of the standpipe as part of a Halloween prank.

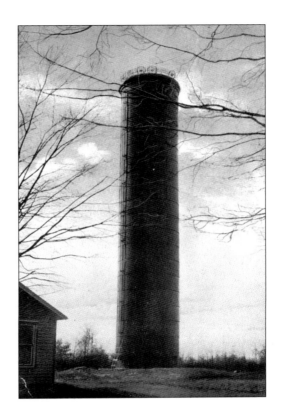

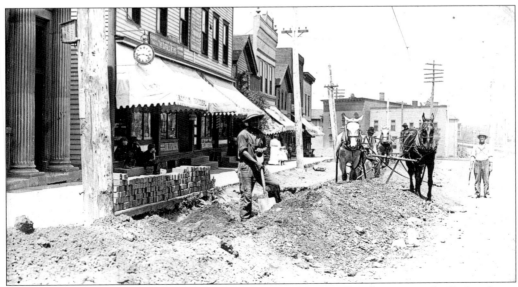

This crew is laying the water main along Commercial Street. Residents were thrilled to learn that after the water main was laid, a new brick-paved street would follow.

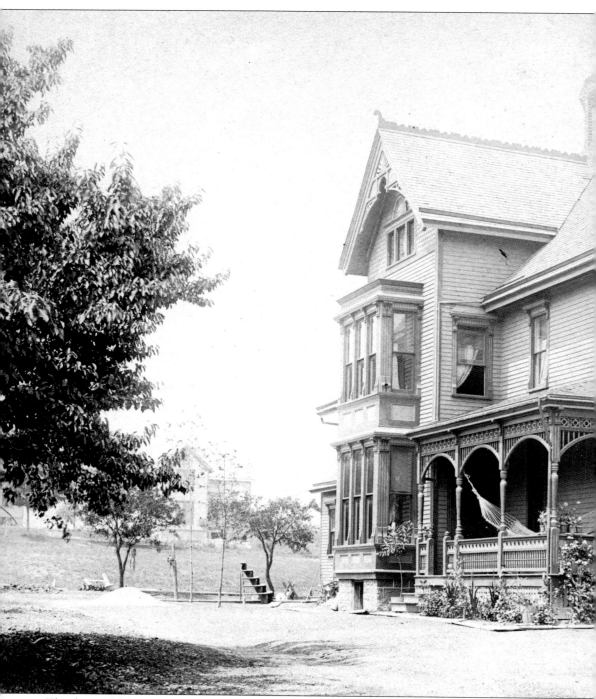

This beautiful home stood at the corner of Main and Center Streets. It was built in 1880 by Orrin Brown, who was town supervisor from 1879 to 1885. It was sold to Julius Schwert around 1900. Schwert continued the political tradition, as he also was supervisor. Between 1900 and 1923, the only years Schwert did not serve were 1904 to 1907 and 1914 to 1917. Meanwhile, he

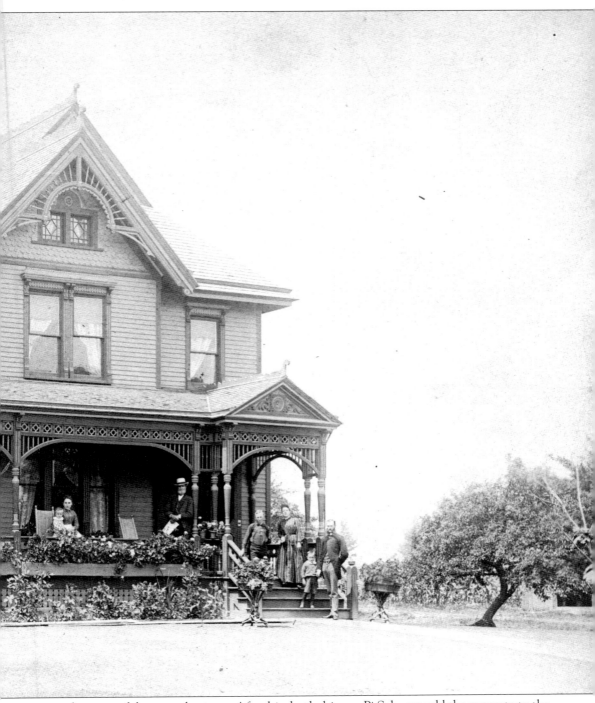

owned a successful grocery business. After his death, his son Pi Schwert sold the property to the federal government. The house was razed to make way for the new post office building. Pi was also involved in politics.

The post office often moved from place to place within a town depending on who was appointed postmaster. This was one of many. The building is a familiar one and is noticeable in several other pictures housing different businesses. At this time, there was also a dentist's office upstairs.

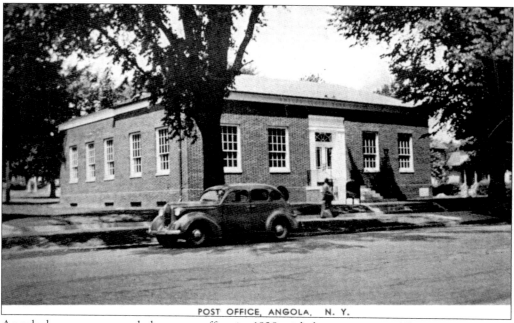

POST OFFICE, ANGOLA, N. Y.

Angola became a second-class post office in 1928 with letter carriers. All streets had to be named and buildings numbered. In 1938, a new brick post office was constructed on the site of the former Schwert home. Because of the quantity of mail that passed through, it became a first-class post office in 1962.

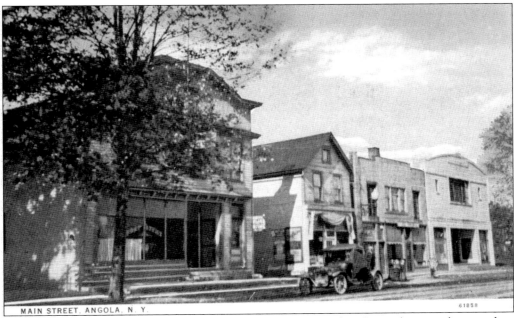

MAIN STREET, ANGOLA, N. Y. 61858

Here are two similar views of the west side of Main Street. The above photograph was taken in 1928 and shows from left to right the post office, Jacobson's store, Landon's store, and the movie theater. The picture below was taken in 1954 and shows the same buildings, including the Angola Variety Store with the Evans Grange upstairs, Cutler's Pharmacy, Western Auto, Joan's Fashion Shoppe, and the New Angola Theatre.

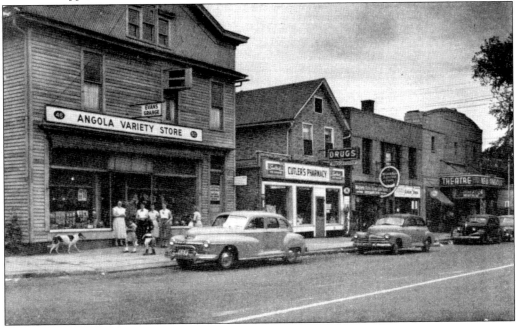

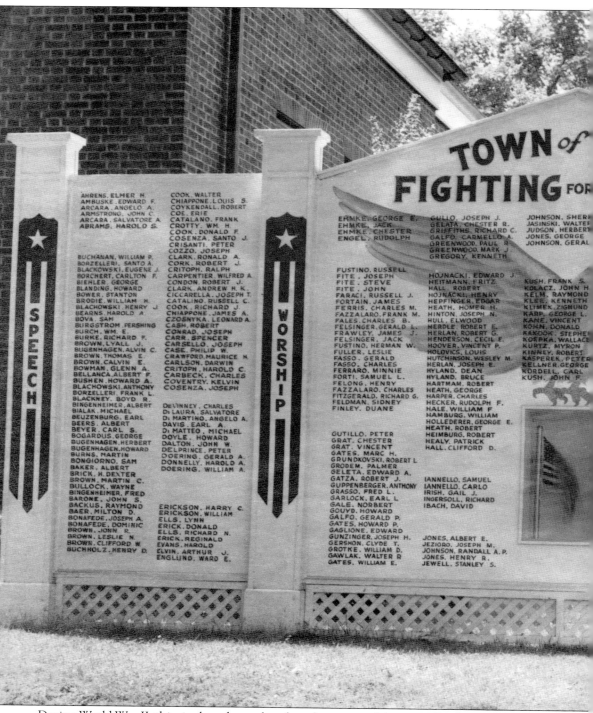

During World War II, this signboard was placed on the corner of the post office lot and dedicated to all the men and women who were serving their country. It listed all of the residents of the town of Evans who were in the service. This is an early picture of the sign as panels were added

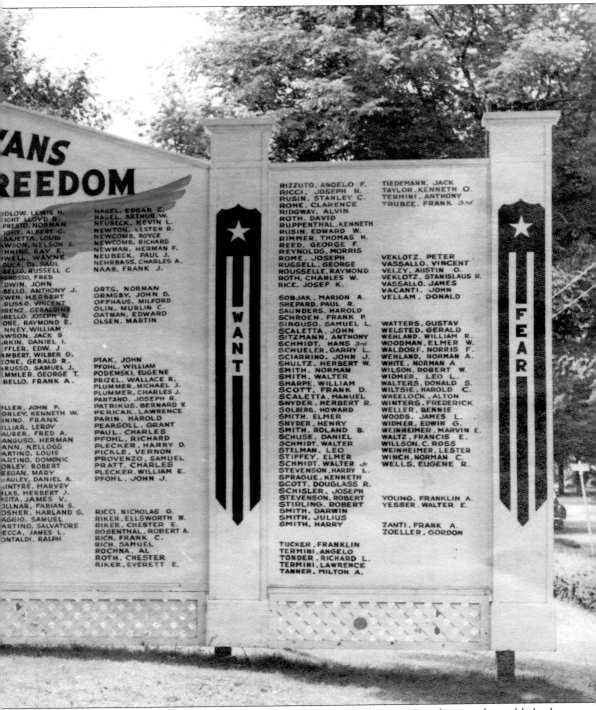

to each side as the war progressed. A news sheet called the *Gleaners' Traveler* was also published as a source of local news for those away from home.

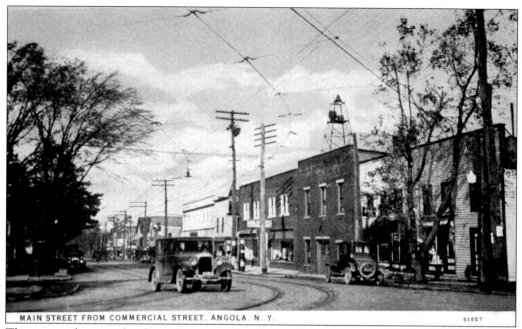

MAIN STREET FROM COMMERCIAL STREET, ANGOLA, N. Y. 61857

These two photographs show the east side of Main Street, but they do not depict the same buildings. The 1928 photograph above was taken from a point farther south on Main Street. The village hall is visible without a balcony. The photograph below is from 1954. The first building, Leone's Restaurant, is behind the center car in the picture above and gives a closer look at the Gulf gasoline station and the liquor store. It shows how busy the village was during those years.

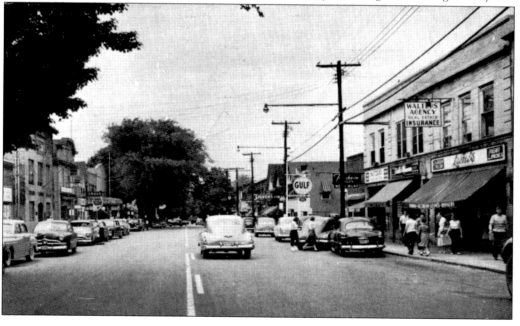

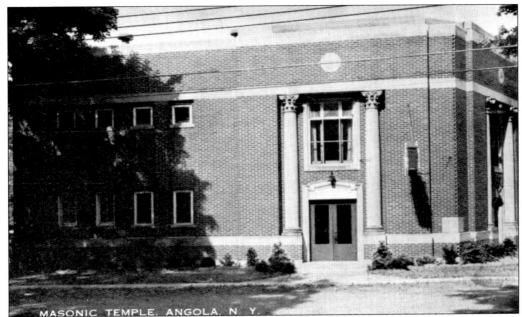

The Masonic temple was completed in 1925 on North Main and Mill Streets. Orders of the Masons and Daughters of the Eastern Star used the building for many years until Angola's group combined with the one in Lackawanna. This building was also used for community functions, weddings, dinners, and general entertainment.

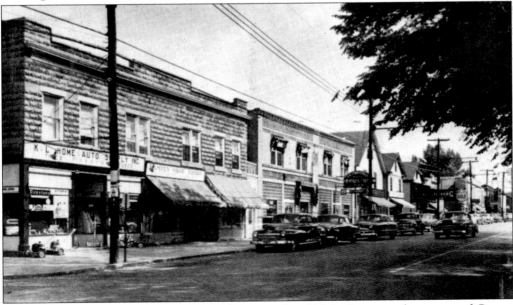

The Amico Block was built in 1914 on the east side of Main Street at the corner of Center Street. The concrete blocks were made by hand by Antonio Amico, with the help of his parents and sister. He was in this country only four years and was just 20 years old when he started this project. Next to that building is the Main Bowling Academy. It was originally a Ford agency, built in 1922. The building still exists, and the name Ford is still visible just below the roofline.

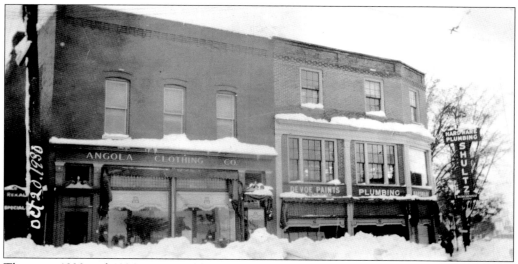

The years 1930 and 1936 saw record-breaking snowstorms. Lake effect was in action even then. The above photograph shows Shultz's store at the corner of Commercial and Lake Streets. Next door is the Angola Clothing Company, which was later called LaClair and Millers. The picture below shows the clock in front of G. R. Kingan Jewelers. Farther down is the Westminster chime clock at the Bank of Angola.

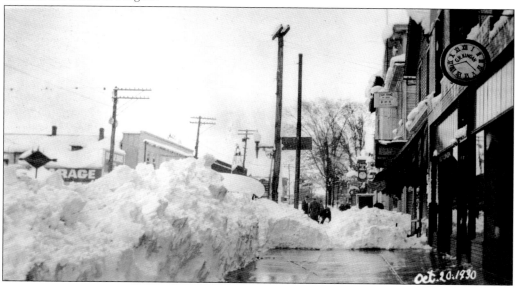

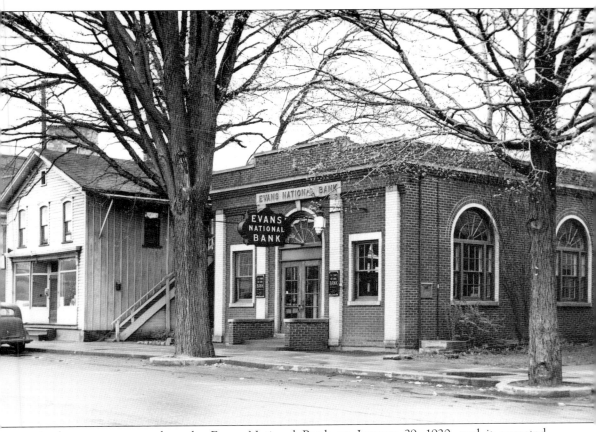

A charter was granted to the Evans National Bank on January 29, 1920, and it operated temporarily in Clow's store on North Main Street. Excavation began the following year for a permanent location near the corner of Main and Lake Streets, shown in the above photograph. George L. Peck was elected cashier and operated the bank unassisted. His wife brought his lunch and stayed at the bank while he went to the post office. In 1949, the bank demolished the adjoining building and constructed an addition. In 1969, it added drive-up windows. The bank has continued to expand and now has 10 branches throughout the western New York area. It recently changed its name to Evans Bank to indicate it still has a small-town feel and a commitment to the western New York area.

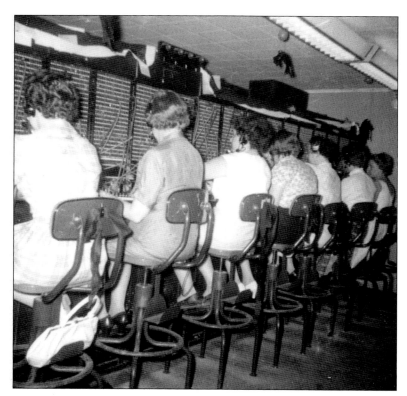

The Angola phone system was one of the last to change over from operators and "number please" to the dial system. On June 18, 1961, the area became the 549 exchange. This photograph was taken of the local operators just before the changeover. There is a black and white crepe paper drape at the top of the board.

What did young people do for fun? Beyond the usual movies and school functions, there was the Angola Rollercade located on Lake Street. Russ and Carm Valvo had run a rink closer to the lake, but then they moved to town and opened this facility. They and their five children lived in a small apartment attached to the rink, and all were involved at some time in the operation of the business. (Courtesy of Bill Haberer.)

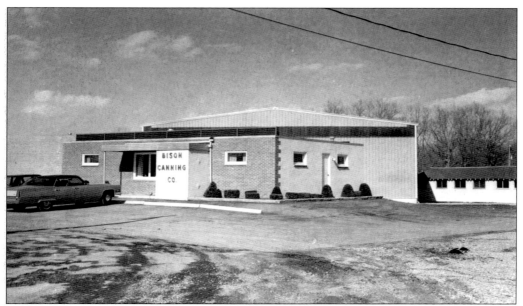

The two pictures on this page were taken more recently, although the businesses are older. Bison Canning Company was founded by Frank Drago and his sons Anthony and Joseph. In 1928, it moved from Brant to South Main Street near the railroad tracks and the Nickel Plate Road station. The business was a major industry in the town and has expanded many times. That expansion has been continued by Goya Foods, who bought the company in 1991.

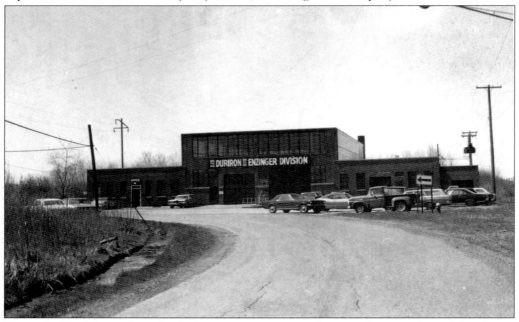

The end of Prohibition brought the brewing equipment industry to the area when a Mannheim, Germany, company set up a branch operation on Hardpan Road known as the Enzinger Union Works. In 1955, it became the Enzinger Division of the Duriron Company, and until it closed in recent years, it made filtering equipment for the food processing and chemical industries.

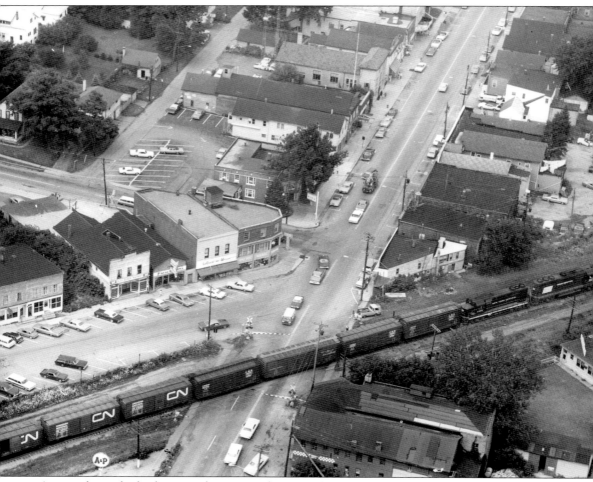

An aerial view looks down on the corner where North Main Street meets Commercial and Lake Streets in the village. Shultz's and Evans Bank are still there today. The locations where LaClair and Miller, Tarner's Pharmacy, and the super market were are now different stores, sometimes changing ownership almost daily. The west side of the street looks about the same, although the names have changed. The east side, however, has seen a number of fires, and many of the buildings are gone. (Courtesy of Richard Miller.)

Three

SUMMER VISITORS

Joseph Bennett, born in 1803, came to the town of Evans in 1820. The 17 year old thought he and his family were just passing through, but they were soon convinced to stay. He kept a journal until his death in 1899 that has provided important information.
He was one of the major influences in the development of the summer camps along the lakeshore.

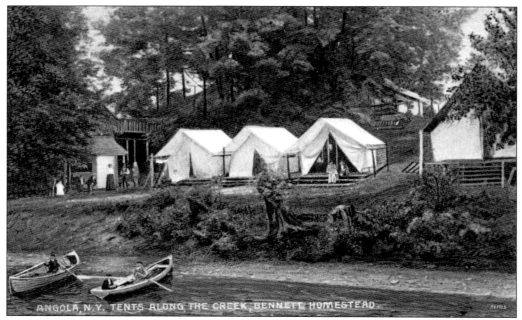

ANGOLA, N.Y. TENTS ALONG THE CREEK, BENNETT HOMESTEAD.

Joseph Bennett owned property on the lakeshore that he farmed, but his life was a busy one. His was a life of political appointments and community activity. In June 1885, Bennett was asked by a family named Walker if the family could pitch tents on the land. Later that summer, another family with a sick child asked the Bennetts if they would accept boarders.

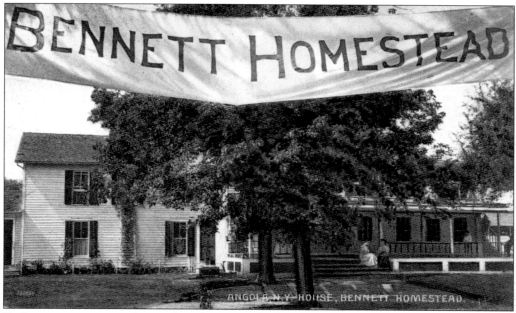

ANGOLA N.Y. HOUSE, BENNETT HOMESTEAD.

Each summer, more and more boarders arrived. There was originally a long tent that served as a dining room, but by 1880, Bennett added a new dining room and raised the house a story. Visitors had to be properly introduced to stay at "the homestead."

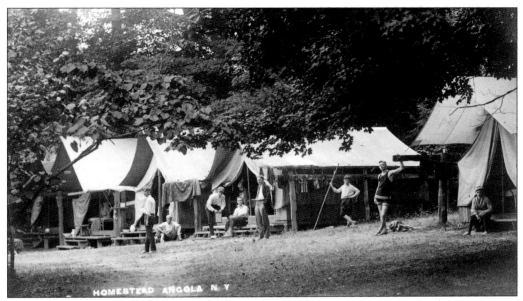

The tents were waterproof and almost as comfortable as home. By the 1890s, there were over 100 visitors every summer who took part in sporting activities such as baseball, fishing, and canoeing. There were concerts and a chance for socialization among the families since they had all been properly introduced. An article in the local paper, the *Angola Record*, said, "There are few places of summer resort in the vicinity of Buffalo that present such combined attractions and which have become so popular with our society people, as the camping grounds near Angola."

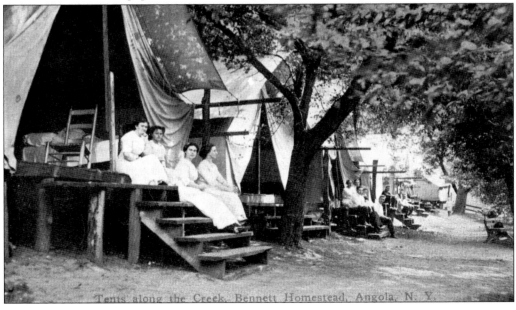

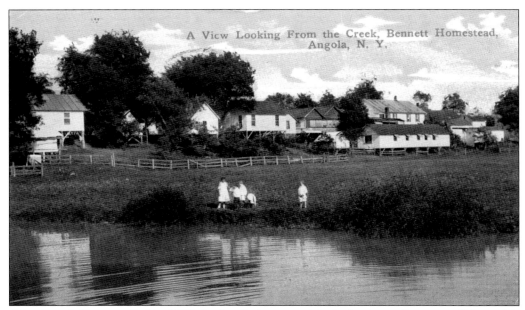

A View Looking From the Creek, Bennett Homestead, Angola, N. Y.

After Joseph Bennett died in 1899, the family kept on with the business. One can tell from this photograph how the accommodations had advanced. There were still tents, but many more permanent buildings had been added.

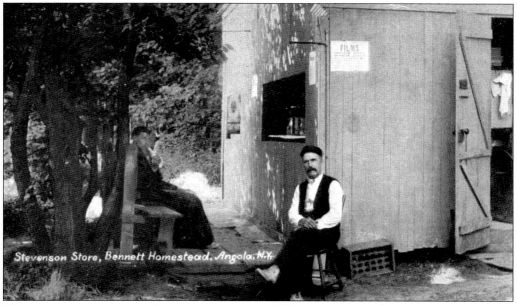

Stevenson Store, Bennett Homestead, Angola, N.Y.

The various camps provided as much as they could for the guests right on the grounds. This small store sold soft drinks, film for cameras, and probably items like shampoo and toothpaste. This postcard has a note on the back that says, "This is certainly some place."

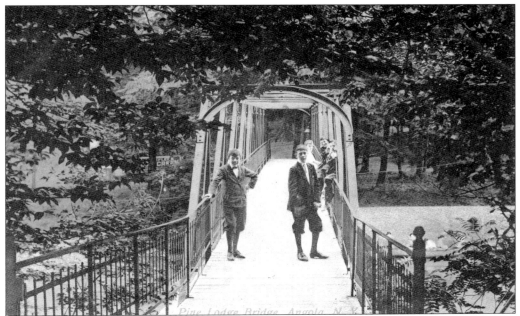

In 1883, Bennett's son Judson built a bridge over Big Sister Creek connecting to 50 acres of property that his father transferred to him. He built a home and a campground first called the Bluffs. This later became known as Pine Lodge.

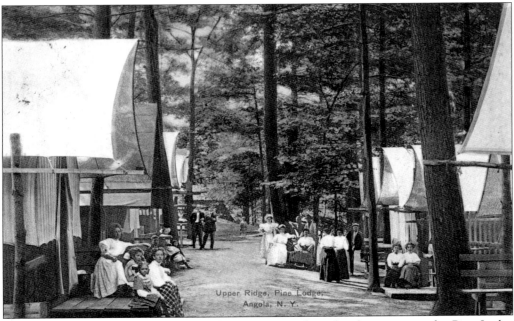

Like the Bennett homestead, many of the summer residents lived in tents on the Pine Lodge property. They were elaborate and almost a home away from home. This is almost like a neighborhood street and provides a comfortable atmosphere.

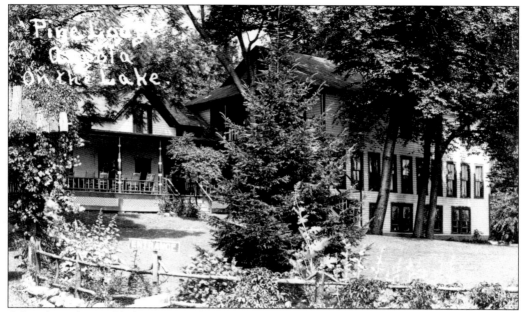

A hotel was later added at Pine Lodge. There was a dining space for 150 people and originally eight bedrooms. This too was expanded as the number of visitors began to rise. These old postcards show two views of the hotel, or house, as they called it. There was a choice of tents or more luxurious accommodations. The fact that they only had eight bedrooms to begin with indicates that most people opted for the tents.

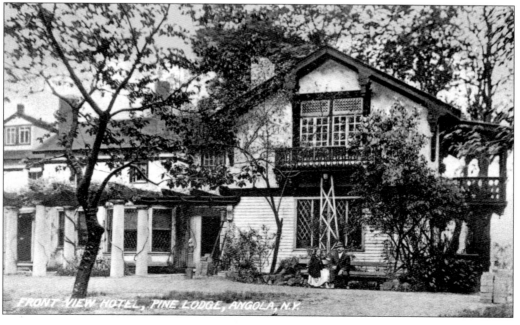

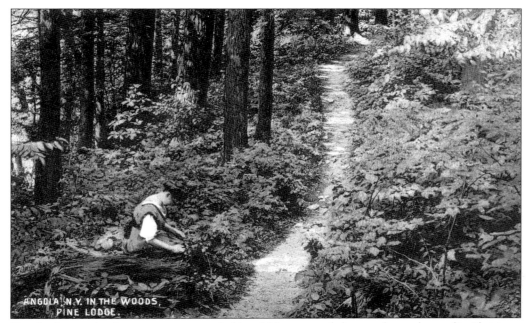

ANGOLA, N.Y. IN THE WOODS, PINE LODGE.

Pine Lodge was in the country surrounded by old forests, and they made good use of it. If visitors did not want to go swimming, boating, or fishing, they could wander the paths through the woods enjoying the flora and fauna. One of the most famous areas at Pine Lodge was the Japanese garden. It was known as far away as California. A gentleman there contacted the historical society because he was doing a book about Japanese gardens and wanted to include this one.

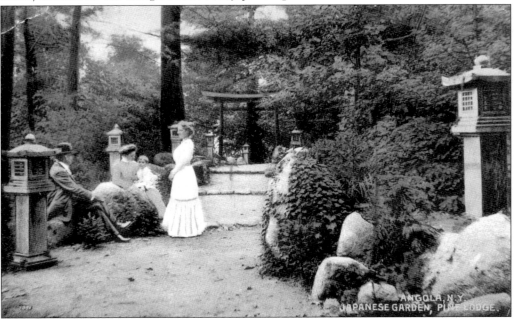

ANGOLA, N.Y. JAPANESE GARDEN, PINE LODGE.

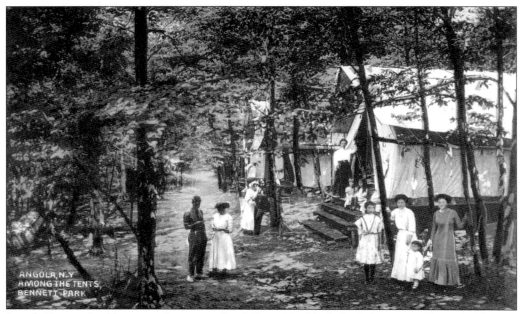

Joseph Bennett's eldest son, Seymour, also followed in his father's footsteps. He took 15 acres of the original land and turned it into what became known as Bennett Park. He had the same cabins, tents, and dining facilities that made the other two areas so popular.

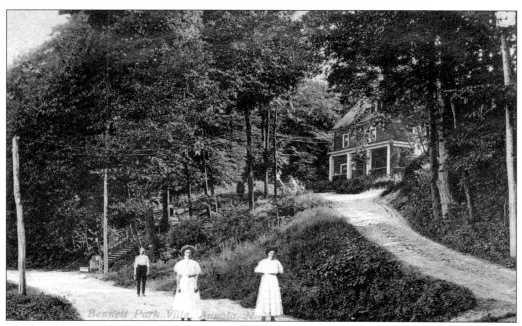

The hotel Seymour built was called Bennett Park Villa and can be seen at the top of the hill. After his death in 1910, the property changed hands and was renamed Woodcrest Beach. In the 1920s, it was purchased by the Catholic Diocese of Buffalo and became St. Vincent de Paul Camp. That is still in operation, but the hotel was demolished at the end of the summer of 2008.

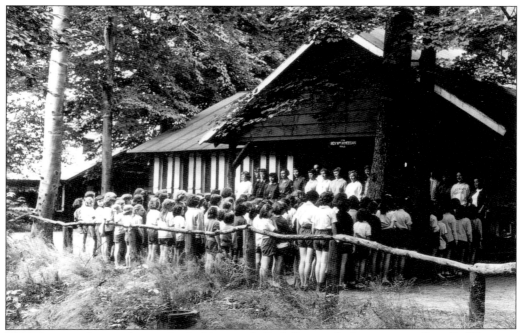

This photograph was taken at the St. Vincent de Paul Camp, which was originally called Bennett Park. It is outside the dining hall on the grounds. (Courtesy of Kevin Siepel.)

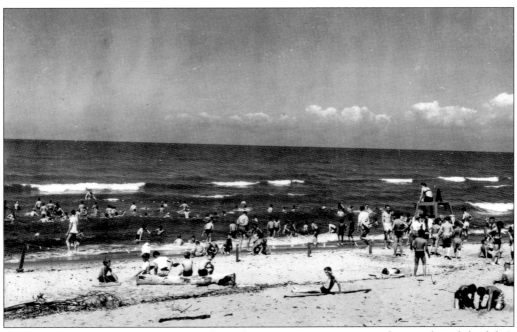

This is a beach scene at St. Vincent de Paul Camp. It serves as a good reminder of the lake's popularity. Coming to the lake and the beach in the summertime was a great escape from the heat of the city, and it was only about 20 to 25 miles south of the city of Buffalo. (Courtesy of Kevin Siepel.)

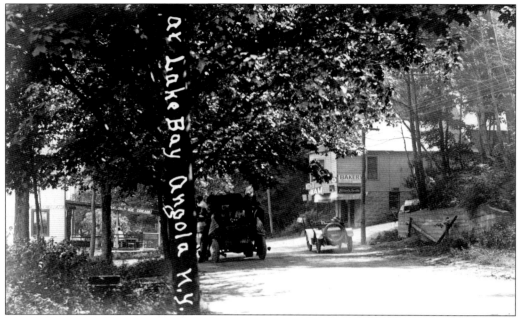

Joseph Bennett sold some of his lakefront property to Hiram (Hi) Backus. Just down the Old Lake Shore Road from the Bennett Homestead was the entrance to the area known as the Grove, or Lake Bay. The entrance was on the right up a rather steep hill. The bakery and ice-cream store were welcome to the summer residents.

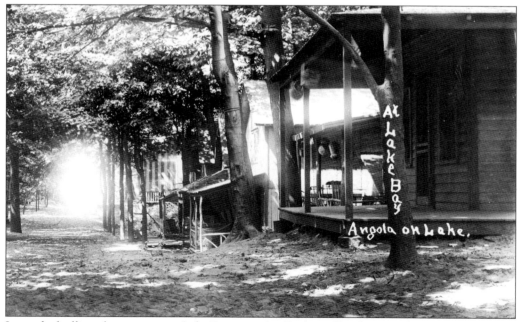

Instead of selling the property at Lake Bay outright, Backus offered 99-year leases to prospective customers who wanted to build vacation homes. This photograph shows a series of homes along Fulton Street.

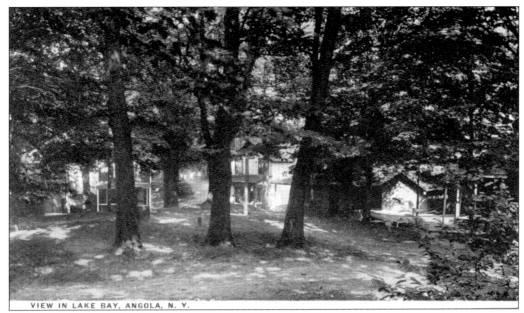

VIEW IN LAKE BAY, ANGOLA, N. Y.

This is another view of some of the summer homes in Lake Bay. There was an abundance of old trees. One could go to the beach for sun or find shade just a few feet away. Although most of these were originally summer homes, many of the residents winterized them and live in the area year-round.

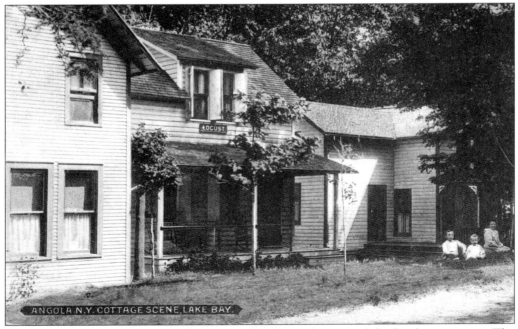

ANGOLA N.Y. COTTAGE SCENE, LAKE BAY.

There were also cottages that could be rented by the week or month by families or groups. The hope was always that they would enjoy themselves so much that they would lease one of the lots and build their own homes.

Wigwam City and Lake Bay

Opens July 3rd and 4th

In Full Blast

and keeps up a full head of steam during the entire camping season. Program Sundays—debate and lectures to cultivate our fertile brain. A prize for the best talent. Prof. Hi, the Naturalist has employed a troup of fourteen—seven ladies and boys—right from Coney Island. Lightning Hi is getting scared—received a wireless message from his grandmother in Mars saying the tail of Halley's comet has knocked the stuffing out of the planet Jupiter and let out all the rag-tag and bob-tails that have been in prison there for a thousand years. They're all coming to Wigwam July the third and stay till cold weather. Pirate Hi—you all voted for me as cheif of police of this town—has built a barbed wire jail at Wigwam, with hooks to hang them on so they cannot kick loose. Suck holes and bums beware Noted characters now on their way from Jupiter. There's Capt. Kidd, who was hung at Newgate, England—Robinson Crusoe and his man Friday with fifty billy goats for prize fighting. The boldest and best gladiator gets a summer resort in Lake Erie. Next comes Sinbad, the sailor. He is now on his way from the North Pole sailing on a slab. Ninety-nine times the sharks at him have grabbed but at the Fourth I will be there.

Who will not give a dime or ten cents to see these ghosts from the Planet Jupiter? Next comes an army of cannibals from the Fiji Islands as hungry as wolves. There's no doubt in my mind that Roosevelt is a bold and reckless man, but I will bet my last dollar he would not go through Wigwam without a battery of Gatlin guns and his rough riders.

The grounds are now fenced in and strictly private. The holder of one of these hand-bills admits the bearer or ten cents at the gate. Gate tender Tom Roat (doody, doody). Come and shake hands with the good old soul.

Do not talk to me about moving pictures or modern amusements, they are all outdone—when you see my whole dam family making motions and not saying a word.

These tickets are good for six days from July the 3d—then a new hand-bill will be on the market.

Remember Wigwam is now enclosed.

From your friend that was and is, and I trust to continue the same, yet might be your worst enemy if you molest anything at Wigwam or Lake Bay—they're both one,

H. A. B. Prop.

Hiram Backus also owned five acres on the other side of the Old Lake Shore Road that he turned into a tourist attraction called Wigwam City. This flyer was an example of what the eccentric businessman used to attract tourists, who paid 10¢ to enter the grounds. There were races and boxing matches as well as lectures on various topics. Ahead of his time, Backus was a proponent of equal rights for women and the Native Americans on the nearby reservation.

94

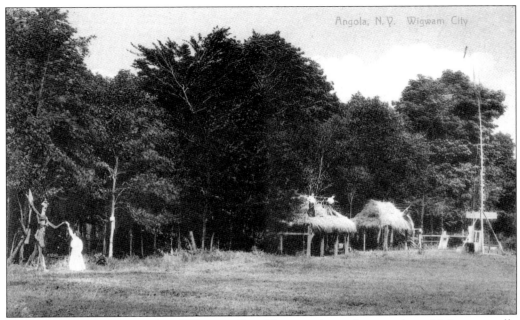

There are several photographs of Wigwam City. This one shows the straw huts. Visitors actually paid to sleep in these huts on the grounds. To the left is one of the many statues he created. Made of driftwood, vegetation, and farm tools, they usually represented biblical characters.

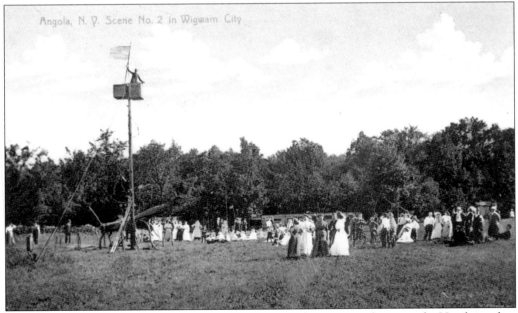

This postcard shows Backus depicted in a crow's nest that was on the grounds. He claimed to receive messages from his grandmother on Mars and gave those messages to the crowds that came to hear him speak.

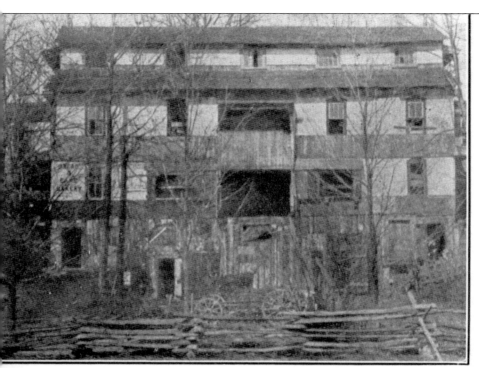

HI'S OLD CASTLE, ANGOLA, N. Y.

This is probably a good example of Hiram Backus's eccentricity. The two middle stories of the building were formerly the Lake Shore Railroad station at Angola. He earned his living as a mover, and when he bought the station in 1880, he moved it to the Old Lake Shore Road and set it on a stone wall with three sides that formed a basement. The front was simply rough planks. The basement was used as a horse shed. The next two stories were used as dance halls. He added the fourth story, which was narrower than the rest and had rooms to rent. People actually lived there. It is said that when dances were held, the entire building vibrated.

A HINT AS TO WHAT MAKES THE KIDS GROW FAT AT CRADLE BEACH:

55 gallons of milk a day
A barrel of crackers a day
100 loaves of bread a day
A barrel of oatmeal a week
A barrel of sugar a week

All of these things cost money. Will you help by sending a subscription? $2.25 pays for food and transportation for two weeks.

FRESH AIR MISSION OF BUFFALO
A. C. GOODYEAR, Treas., 19 W. Tupper Street

I gained a pound and a half a week

The Fresh Air Mission was created in 1888 at a time when diphtheria, cholera, and typhoid were major killers of children. Cradle Beach Camp provided a place where underprivileged youngsters could enjoy water and sun and have enough to eat. Putting on weight was the number one objective. An old farmhouse was bought from Christopher Small on the Old Lake Shore Road and became the main building for the camp. The children lived in tents and came to the farmhouse for meals with fresh vegetables and homemade bread. They were weighed at the beginning and end of each week. More agencies became available to address these original needs, and Cradle Beach changed its focus. In 1947, physically handicapped children attended for the first time. The camp has now moved to a new location about a mile down the road. The camp shown here has been replaced by beautiful lakefront homes, but the stone wall has survived.

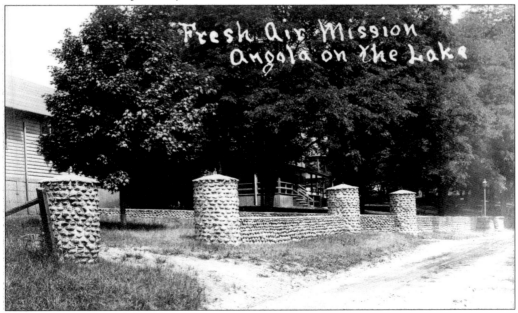

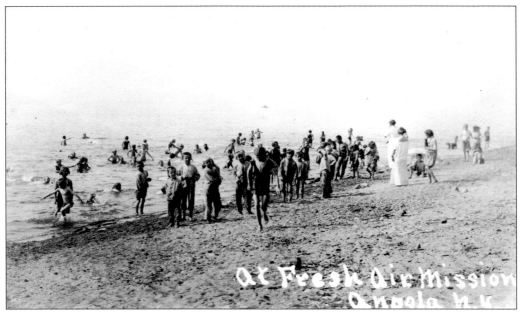

This scene is of a group at Cradle Beach. Many of the children had never been to a beach before, and it brought a wonderful new experience their way. A sandbar along this stretch of shoreline made it wonderful for inexperienced swimmers, as the water remained relatively shallow.

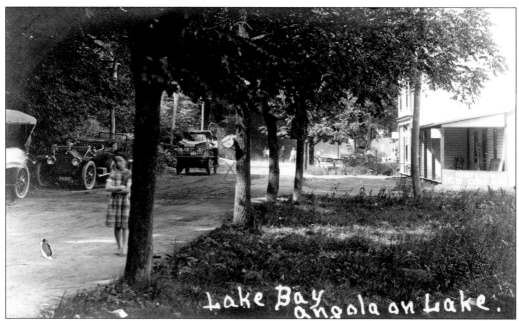

This is similar to the photograph on page 92, but this time, the entrance to the Grove is to the left, marked by the x. The ice-cream store is seen to the right. This became an entrance to another form of entertainment for the family known as Lalle's Park.

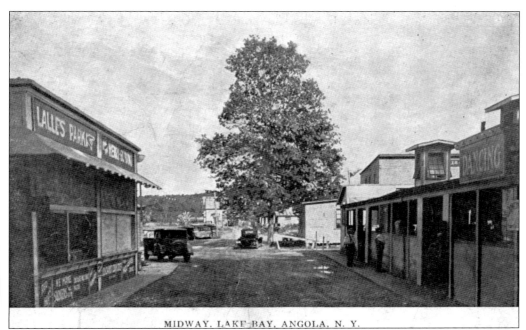

MIDWAY, LAKE BAY, ANGOLA, N. Y.

Here are two photographs of Lalle's Park; the one below was taken during the winter when the park was closed. Opened around 1906, the park had amusements for adults and children alike, including a Ferris wheel, a carousel, a penny arcade, and a dance hall. In later years, a bingo game was added. One could play almost every afternoon and evening. After the park closed, a popular bar known as the Du Drop Inn was located here.

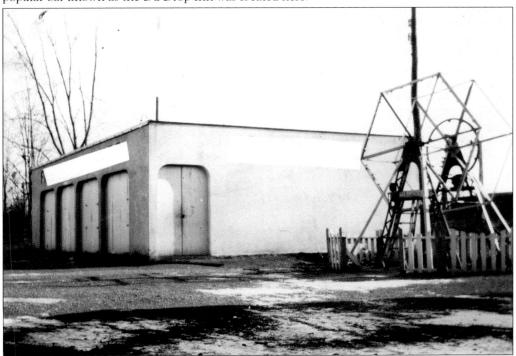

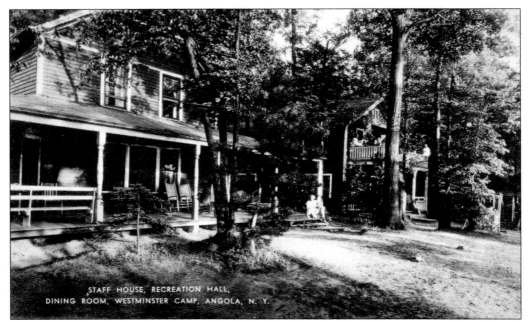

STAFF HOUSE, RECREATION HALL,
DINING ROOM, WESTMINSTER CAMP, ANGOLA, N. Y.

Other camps spread from one end of the town to the other. Entering the Old Lake Shore Road from Bennett Road where the Bennett Homestead was, one could travel all the way to Evangola State Park, passing all kinds of different retreats. Some were church sponsored, some were affiliated with the YMCA, some were run by charitable organizations, and some were in private hands. These photographs are two examples. Above is Westminster Camp, and below is Camp Whitford, which was sponsored by the YMCA. (Below, courtesy of Bill Haberer.)

TENT STREET, CAMP WHITFORD BRANCH, Y. M. C. A., ANGOLA, N. Y.

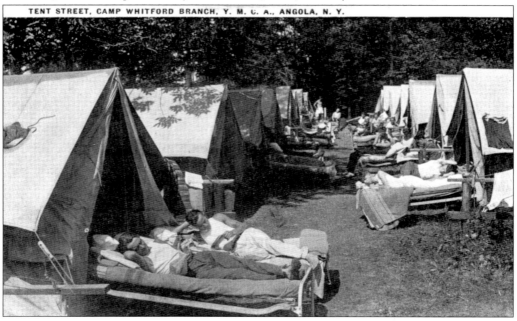

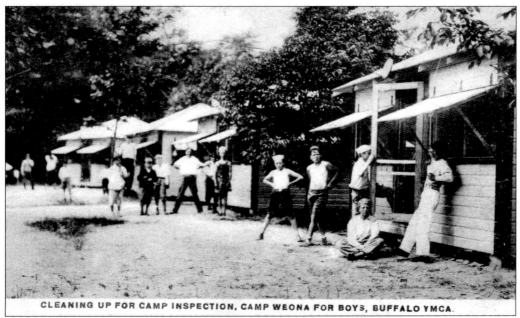

CLEANING UP FOR CAMP INSPECTION, CAMP WEONA FOR BOYS, BUFFALO YMCA.

These photographs depict two more camps that brought in summer visitors. Above is Camp Weona for boys, sponsored by the YMCA. The photograph indicates they were cleaning up for an inspection, probably some time in the early 1930s. Camp Ahlers is pictured below. Often if one had ample property, preferably lakefront, and a place for tents or cabins, it was possible to set up a reputable business for the summer, as more and more people wanted to escape the city. (Above, courtesy of Bill Haberer.)

CAMP AHLERS, ANGOLA, N. Y.

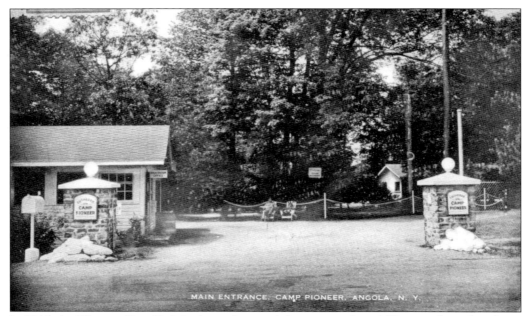

MAIN ENTRANCE, CAMP PIONEER, ANGOLA, N. Y.

In 1945, the Western New York Lutheran Laymen's League purchased 75 acres of woods, cabins, and so on from the YMCA, and it became Camp Pioneer. Ownership was transferred to the Lutheran Church Missouri Synod in 1991. Although it has a church connection, the camp is open to all. In 1976, it became more than just a summer camp when it decided to open year-round. Above is the main entrance to the camp. The dining hall is shown below during the summer. There are programs open to children, teens, and seniors at various times of the year. (Courtesy of Bill Haberer.)

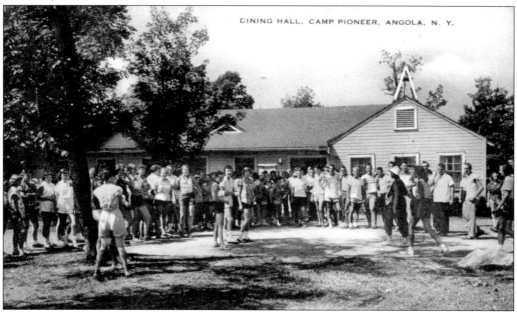

DINING HALL, CAMP PIONEER, ANGOLA, N. Y.

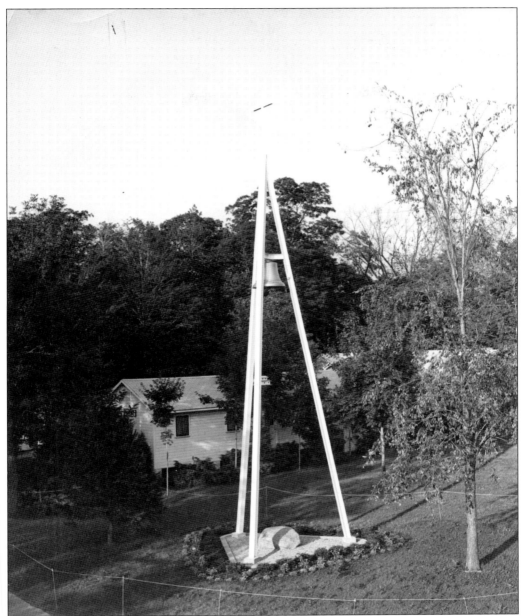

The bell tower at Camp Pioneer was often the location for outdoor services and activities. Today the camp serves over 10,000 people annually and is available for community, family, and camp activities.

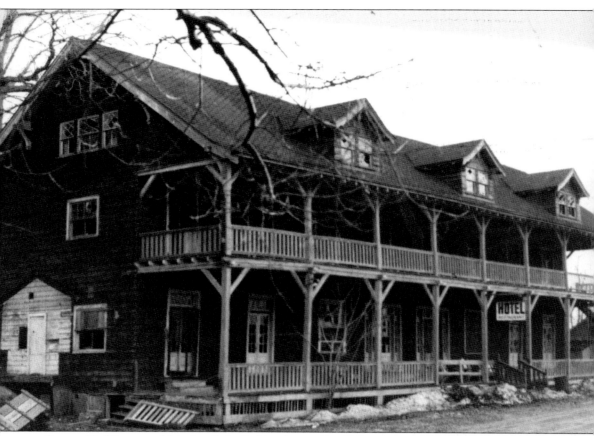

George N. Pierce and his family built bicycles in the 19th century. The family business was transferred to those who ran the Emblem bicycle company in Angola. At the dawn of the 20th century, they became involved in the automobile business and manufactured the Pierce Arrow Automobile. The family's summer home was built about 1894 right at Sturgeon Point where the marina is located today. It was an example of what was called resort architecture and was modeled after what was called Adirondack Rustic. After the family sold the house, it became an inn and tavern called the Sturgeon Point Lodge. It changed hands several times, and by 1970 when this photograph was taken, it was being used as storage by the town. It burned in 1982.

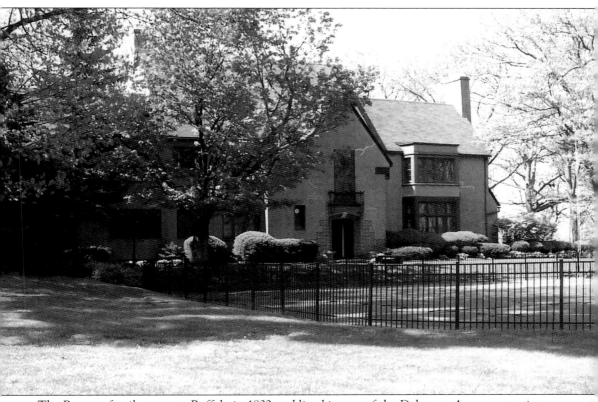

The Rumsey family came to Buffalo in 1832 and lived in one of the Delaware Avenue mansions before they decided to build a summer home in Evans. At one time, they owned 22 of the 43 square miles of the city of Buffalo. Much of this land was loaned to the city for the Pan-American Exposition of 1901. Ruth, the daughter of Dexter Rumsey, married "Wild Bill" Donovan in 1914. This is the house that Dexter built. The property is now a complex of condominiums called the Bluffs, but the house still remains. It is the social center for the Bluffs, providing a place for meetings and rooms for guests of the residents.

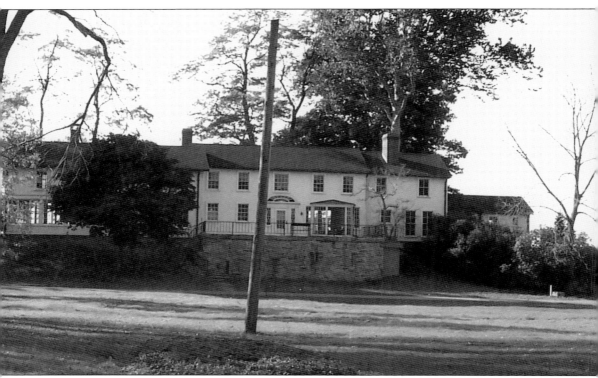

Henry Wendt and his brother William were the founders of the Buffalo Forge Company in Buffalo. Henry built this house and named it Ridgewood. The house has been vacant for a number of years, and the property is owned by Erie County at the present time. It is called Wendt Beach, and there is public access to the beach. The house is not visible from the road, but there is a parking lot just to the right of the area in the photograph. The original stables are now restrooms for the visitors to the park, and other buildings are still in existence. There are soccer fields between the house and the road for some of the youth leagues.

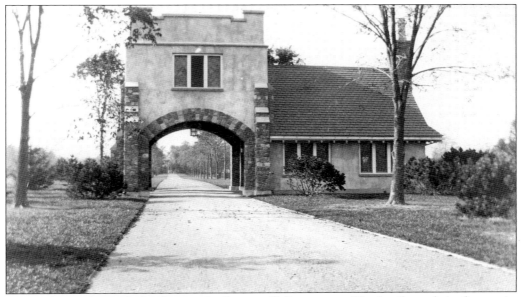

This is the gatehouse for Lochevan, the Spencer Kellogg estate. The family made its fortune in linseed oil, which they started producing in 1824. The estate was built around 1895 and was the summer home for five generations of the family. They had connections to many other families in the area and were mainly responsible for the development of the hunt club and polo league, along with other activities.

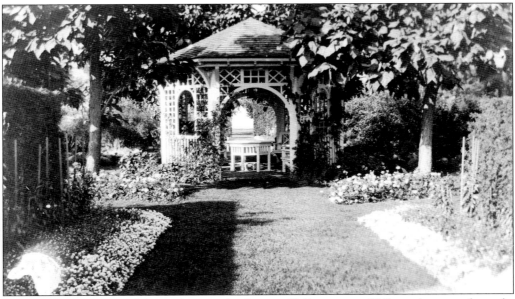

This gazebo was a part of the gardens on the Spencer Kellogg estate. Kellogg also owned a yacht that he used to get back and forth to the city and his work in the summertime. Many of the other residents had yachts as well, and they often raced to the city in the morning. The estate is now home to Claddagh, a residential home for adults with developmental disabilities.

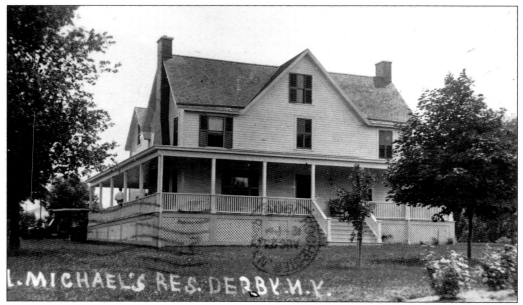

Edward Michael was born in 1850. His father was the owner and manager of the American Hotel. Legend has it that Abraham Lincoln was a guest at the hotel on the way to his inauguration in 1861. Michael played leapfrog with Willie and Tad Lincoln, and supposedly their father joined in. Michael owned this home in Derby since 1886. (Courtesy of Bill Haberer.)

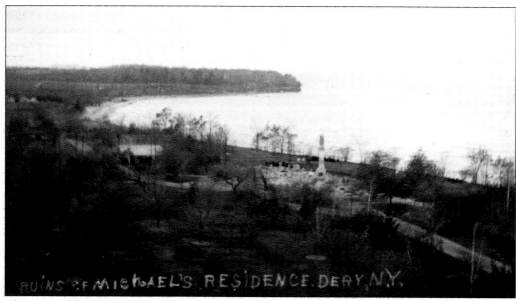

The original home burned, as shown in this photograph, but the extent of the property is visible. After his wife's death in 1934, he built Hickoryhurst on the site. It was a 40-room house where he lived with his three daughters, Clara, Jeannette, and Edwine. They never married.

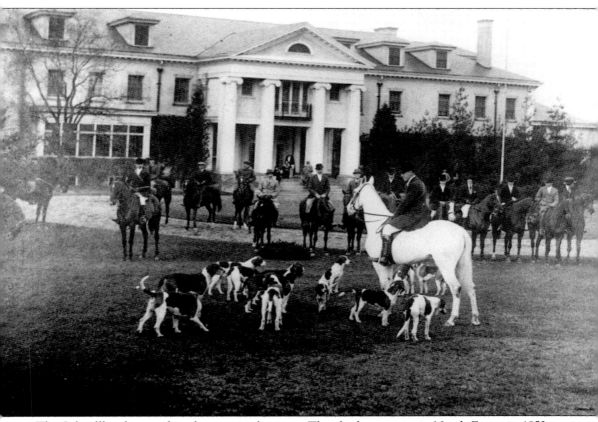

The Schoellkopfs started in the tannery business. They had a tannery in North Evans in 1853 and branched out into milling and breweries. In 1877, Jacob Schoellkopf successfully took over the bankrupt power development project in Niagara Falls. His summer home was in Hamburg just across Eighteen Mile Creek. His daughter Helen married Hans Schmidt. Schmidt came to Buffalo at the age of 17 and became a salesman in Schoellkpf's company. He became a partner and later president, and he was also director of the Niagara Falls Power Company. In 1918, he and Helen moved with their three children to this estate they built in Derby. In 1947, the estate was sold to the St. Columban Layman's Retreat League. The house has basically been unchanged.

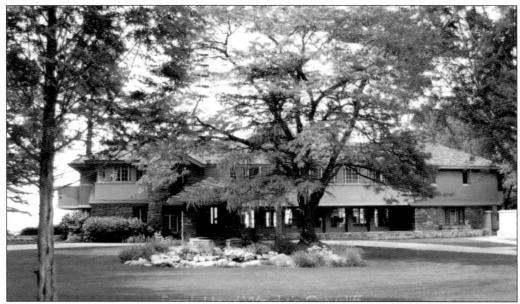

These are summer and winter photographs of Graycliff, the summer home of Darwin and Isabel Martin. They were owners of the Martin house in Buffalo, designed by Frank Lloyd Wright. When they decided to build a summer home in Derby, they again called on Wright to do the design. Graycliff was built in 1927, and the Martins lived there until Isabel's death in the 1940s. The house was sold and lived in by the Piarist Fathers for over 40 years. When the priests put the house on the market, a group of individuals formed the Graycliff Conservancy and were able to save the house from developers who were going to tear it down and build condominiums. The house is now open for tours between April and November each year.

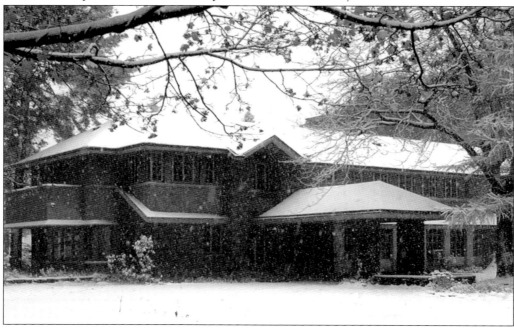

Four

PEOPLE AND EVENTS

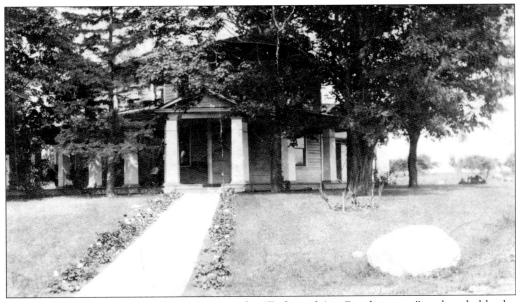

This is the birthplace of Willis H. Carrier, the "Father of Air-Conditioning" and probably the most famous resident of Evans. Originally the Carrier farm, it is now the Veterans of Foreign Wars post on Route 5 near Lake Street. In 2000, *Time* magazine named Carrier as one of the 100 most influential people of the 20th century.

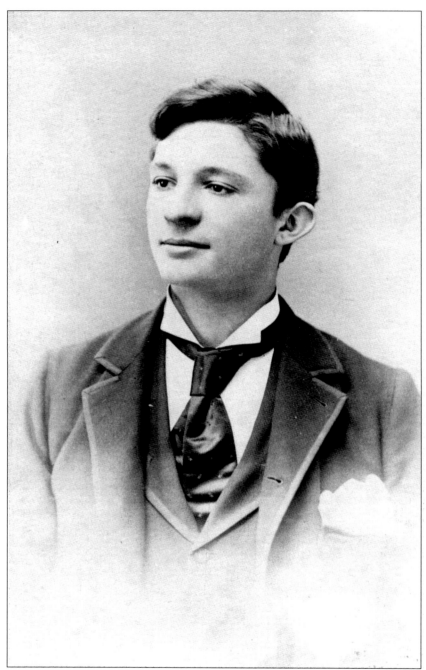

Willis H. Carrier was born on November 26, 1876, the son of Duane and Elizabeth (Haviland) Carrier. He attended the Evans District No. 2 school, now the home of the Evans Historical Society. He often gave credit to his mother for stimulating his intellectual curiosity and leading him to his future career. He graduated from Angola High School in 1894 and went to live with relatives in Buffalo to earn money for college. He won a state scholarship and was able to go to Cornell University sooner than expected. He is pictured here at his high school graduation.

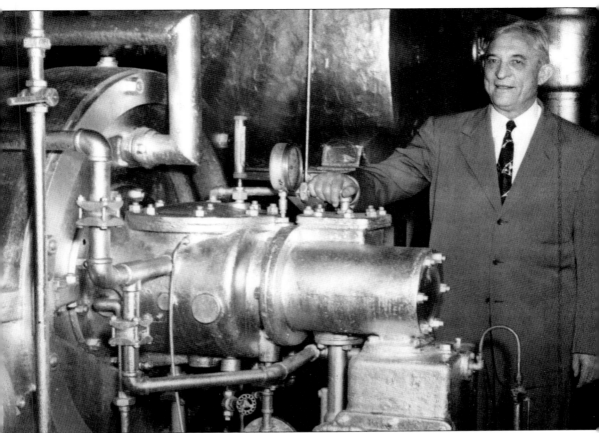

After his graduation from Cornell University, Willis H. Carrier returned to the area and went to work for Buffalo Forge. This photograph shows him standing alongside the first centrifugal machine that made air-conditioning practical. The machine is now on display at the Smithsonian Institution in Washington, D. C. Along with a few of his coworkers, he left Buffalo Forge to begin his own company, now known as the Carrier Corporation.

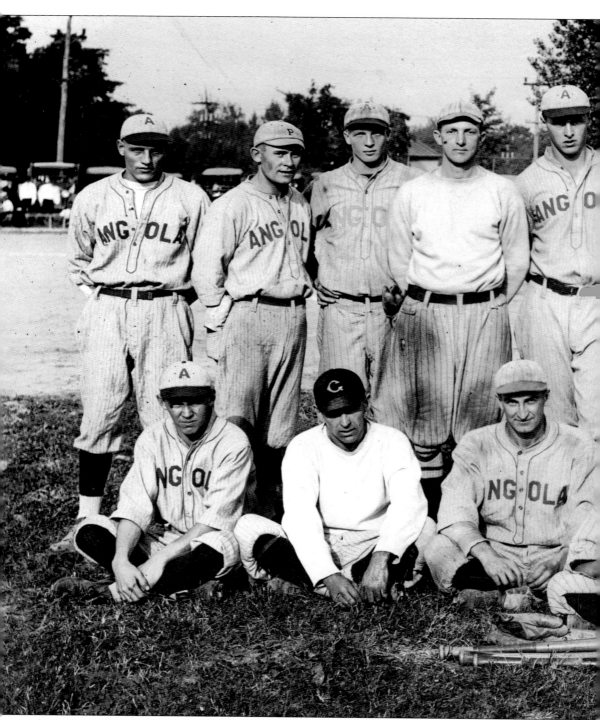

Sports were always an important part of town life. In the 1920s, articles about the local baseball team were usually on the front page, often relegating national news to secondary pages. This is just a representative team from 1922, but locals will recognize many names. From left to right are

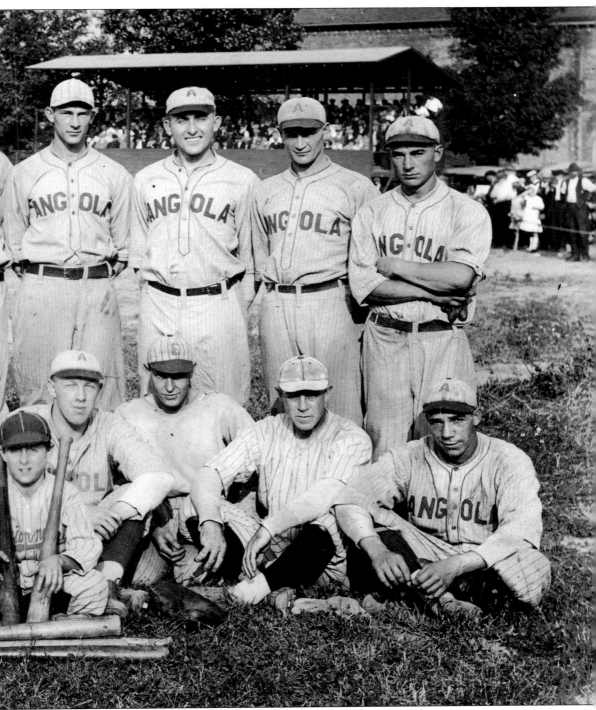

(first row) Norman Whitty, Allie Guest, Pi Schwert, Leo Widmer, Harold Velsey, Lee Twitchill, John Ducher, and Dutch Basil; (second row) Frank Houston, Leo Tobola, Rudy Kinn, Newt Jackle, Vincent Woods, Lefty Crandall, Harry Gilbert, Eddie Lowenstein, and Glen Erick.

On His Record Re-Elect
PIUS L. SCHWERT

No. 9-B

SECOND
ROW

No. 9-C

THIRD
ROW

Your Candidate For
CONGRESSMAN
42nd District

Pi Schwert was born in Angola on November 22, 1892. He was an athlete, a businessman, and a politician. He played baseball for the New York Yankees from 1914 to 1917; he was a catcher. He was president of the Bank of Angola from 1921 to 1931. He started his political career in the 1930s serving six years as Erie County clerk before running for Congress in 1938. Elected representative of the 42nd Congressional District, he served from January 3, 1939, until his sudden death in Washington, D.C., on March 11, 1941. He died in the arms of Sen. James Meade after suffering a heart attack. Senator Meade also had a summer home in Evans. It was recently discovered that Millard Fillmore had a summer cottage in Evans for a year or two as well.

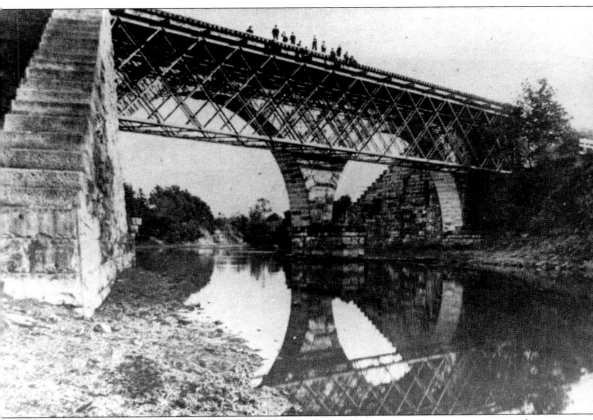

This bridge over the Big Sister Creek near Mill Street was the scene of a major train wreck on December 18, 1867. It was called the "Angola Horror" by the media and became a national story. As the train went over the bridge, the end car jumped the tracks, uncoupled from the train, and went over the bank into the creek. The next car soon followed. Both cars rolled over on their way down the embankment, and because they were heated by coal stoves, both cars burned. Villagers came as quickly as possible to the scene, and the injured were taken to nearby houses, but nearly 50 people were killed, and many more were injured. A marker has been placed near the spot where this accident took place.

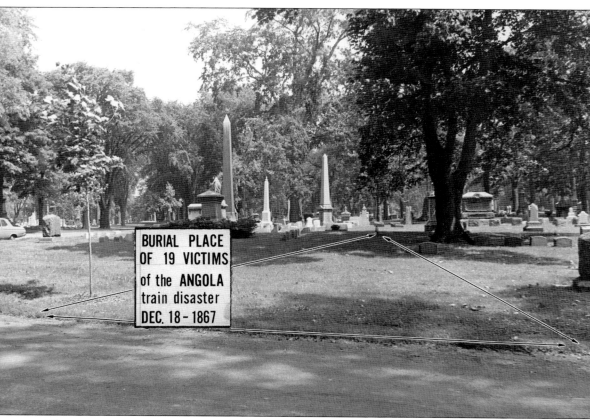

There were victims that were so badly burned that they could not be identified. They were buried in a mass grave at Forest Lawn Cemetery in Buffalo. Now that there is a marker at the site, something needs to be done to see that the victims are remembered here also. One interesting addition to this story has recently come to light. It seems that John D. Rockefeller was scheduled to take this train but was running late and missed the connection. His luggage, however, was on the train and was completely destroyed. As a late arrival, Rockefeller would most likely have been seated in one of the end cars. He was only 28 at the time and went on to have a productive career.

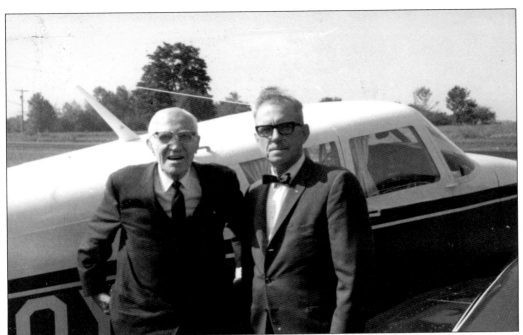

Jennings Piper came to the town of Evans in the 1940s living on Eden-Evans Center Road. He lived a quiet, normal life here, but his grandson was William Thomas Piper Sr., the president of Piper Aircraft Corporation, known as the "Henry Ford of aviation." In 1969, William Piper came here to dedicate a marker at the historical society. He was 88 years old at the time. The photographs show him with A. W. Lossing (right, above) and Howard Schoetz (right, below).

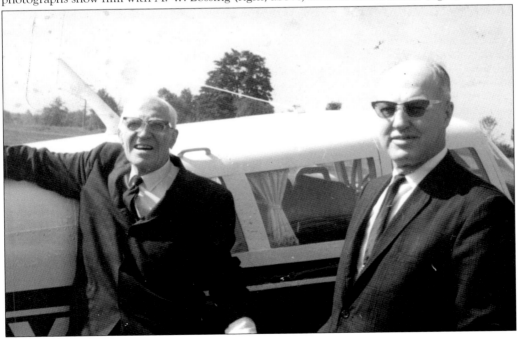

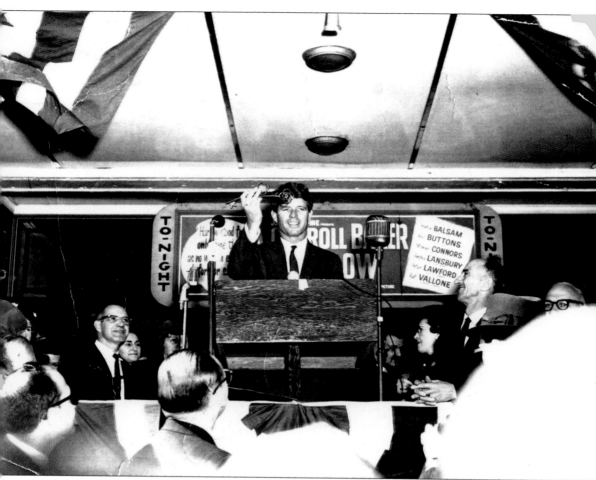

Another famous visitor to town was Robert Kennedy. During his campaign for New York senator, he visited Angola on October 17, 1965. This photograph shows him receiving the key to the town on the steps of the New Angola Theatre. There were huge crowds listening to him and the town's Democrats speak.

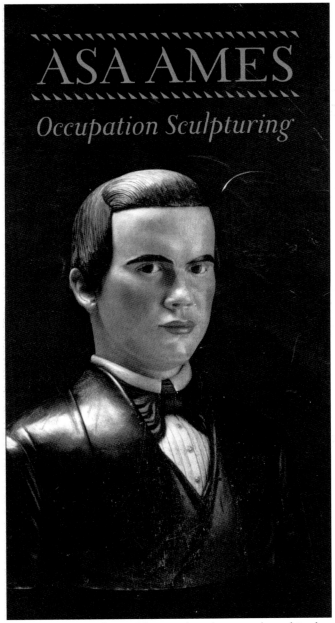

ASA AMES
Occupation Sculpturing

Asa Ames is a rather mysterious figure. Not much is known about his short life other than the fact that he was tremendously talented. He was born in 1824 in Evans. The 1850 census shows him living with Dr. Harvey Martin where it is believed he was undergoing treatment for tuberculosis. He died in 1851 at the age of 27. In the too short span of his life, he was able to create a small legacy with his art. On the census, he listed his occupation as sculpturing. There are approximately 12 wood sculptures that have been found and attributed to Ames. There was a showing of his works at the American Folk Art Museum in New York City in 2008. This bust, called *Head of a Boy*, is regularly on display at the Fenimore Art Museum in Cooperstown. (Courtesy of the Fenimore Art Museum, Cooperstown, New York.)

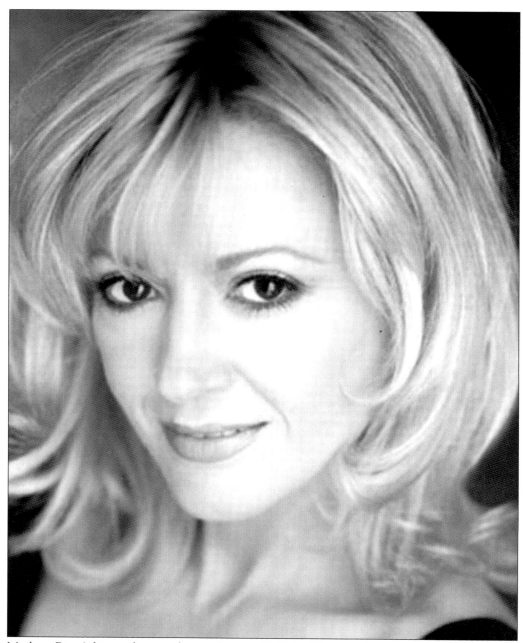

Marlene Ricci's biography says she was born in Buffalo. That may be true, but she was brought up in Angola. She began singing at age six and was encouraged by her dad who drove her to local singing engagements before she was old enough to have a driver's license. She spent years performing with Frank Sinatra, which gave her the exposure she needed to become a regular in Las Vegas. She was inducted into the Buffalo Music Hall of Fame in 2004. Many Lake Shore Central School District graduates remember when she and Clint Holmes performed for their friends, and everyone knew they would be successful. (Courtesy of Joseph Ricci.)

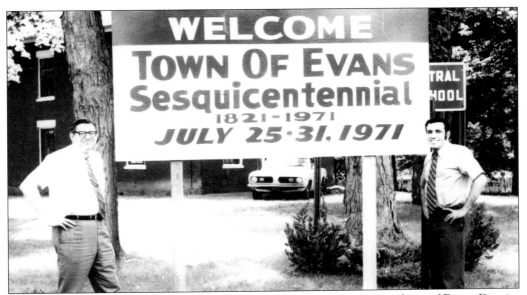

In July 1971, the town of Evans held its sesquicentennial. This sign is in front of Evans District No. 2, which was still being used as a school by the Lake Shore Central School District. However, it contained exhibits for the celebration and soon became the property of the town and the historical society. The two gentlemen are Robert Catalino, Evans town supervisor, on the left, and Anthony (Neno) LaRusso on the right.

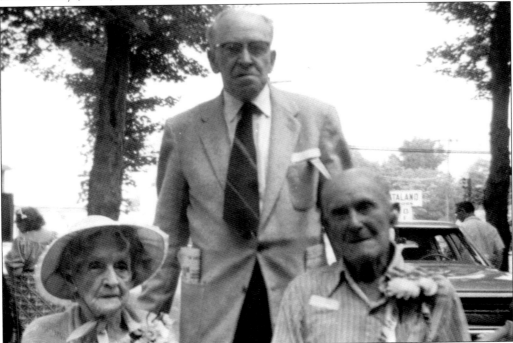

At the sesquicentennial celebration, the oldest residents of the town were honored. The oldest woman was Hattie Merry, and the oldest man was William Stevenson. The man in the middle is Donald Cook, the town historian.

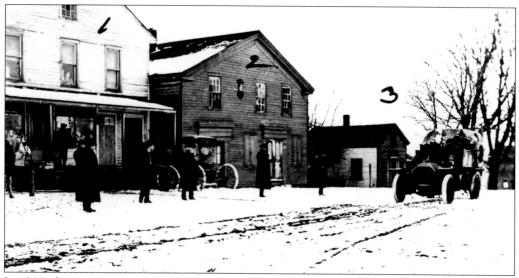

In 1908, there was an automobile race around the world. It started in New York City and headed west. Once it reached the West Coast, it went up to Alaska and was taken by ship to Russia. It crossed through Siberia, and the race ended in Paris, France. The race passed through the town, and this photograph shows the German car Protus climbing the hill on Route 5 near district school No. 2.

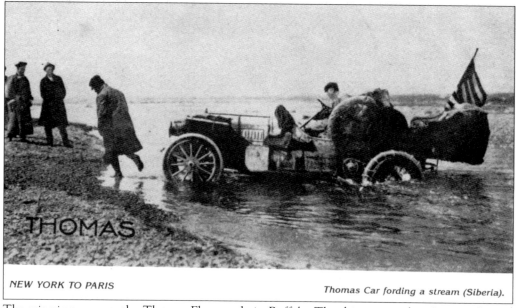

NEW YORK TO PARIS

Thomas Car fording a stream (Siberia).

The winning car was the Thomas Flyer made in Buffalo. The driver moved to Springville and opened a car dealership there. In 2008, the centennial year, his grandson toured the area doing presentations about the great race.

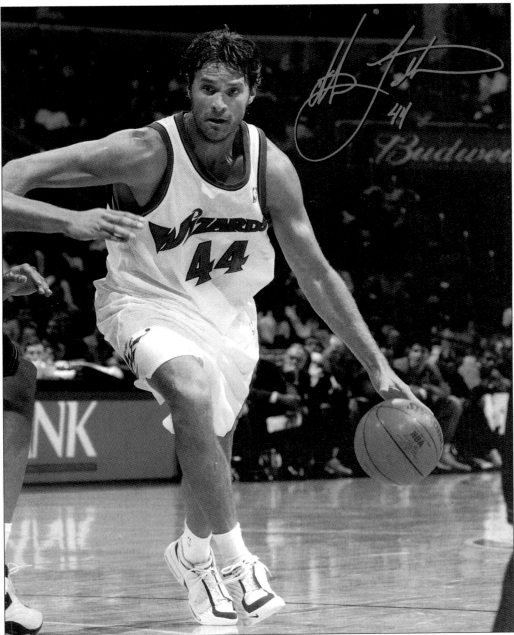

Christian Laettner was born on August 17, 1969, and attended local elementary schools before going to the Nichols School in the city of Buffalo. He was always true to his roots, however, saying he was from Angola. His career at Duke University made him one of the best-known college basketball players in the United States, and he was the only nonprofessional player on the Dream Team in the 1992 Olympics that won the gold medal. He was drafted by the Minnesota Timberwolves in 1992 and played for several NBA teams before he retired. He was on the 1993 all-rookie team and the 1996 all-star team. The town's only other professional athlete is Patrick Kaleta, who plays hockey in the NHL for the Buffalo Sabres. (Courtesy of the Laettner family.)

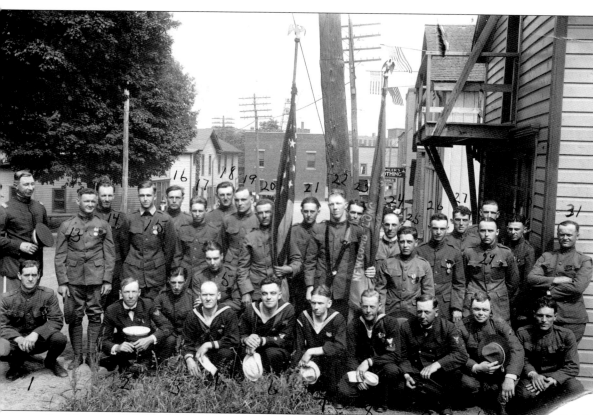

For Memorial Day in 1921, this picture was taken of World War I veterans. None of them were really famous, but they were important to the residents of this town. Pictured from left to right are (first row) Josh Billings, Louis Ingersoll, Harlen Hainer, Henry Brand, Charles Tingley, Everett Schlender, Reed Williams, Nelson Ingersoll, Eldred Brown, Clarence Ells, and Frank Houston; (second row) Edgar Gritman, Carl Meisner, Miles Landon, Merritt Landon, Ray Newcomb, Arthur Oatman, Ray Bugenhagen, Ward Houston, Ralph Walters, Stanley Hammond, Harold Velzy, Donald D. Cook, Anthony Ellis, Norman Peck, Clayton Hanson, Henry Pflanz, Henry Hartman, Fred Sweetland, Rollo Annice, and Jess Clow.

There is a popular local legend about someone called the "Pigman." Here is Luther Holland, not the Pigman, but the road where Holland lived and that bears his name was nicknamed "Pigman Road." Holland Road is a spooky, desolate area, and starting around 1980, there were rumors of ghostly forms and mysterious sightings. One of these was a man, terribly disfigured and possibly burned, who the teenagers labeled the Pigman. Where do the stories come from? Perhaps from the presence of a butcher at one end of the road who used to put the heads of butchered pigs on his fence, or perhaps from a local butcher who was murdered and hung from a hook in his shop. No one knows for sure, but the stories go on.

ACROSS AMERICA, PEOPLE ARE DISCOVERING SOMETHING WONDERFUL. *THEIR HERITAGE.*

Arcadia Publishing is the leading local history publisher in the United States. With more than 3,000 titles in print and hundreds of new titles released every year, Arcadia has extensive specialized experience chronicling the history of communities and celebrating America's hidden stories, bringing to life the people, places, and events from the past. To discover the history of other communities across the nation, please visit:

www.arcadiapublishing.com

Customized search tools allow you to find regional history books about the town where you grew up, the cities where your friends and family live, the town where your parents met, or even that retirement spot you've been dreaming about.